JERSEY
IN
50
BUILDINGS

TRACEY RADFORD

AMBERLEY

For my family
x

First published 2023

Amberley Publishing, The Hill, Stroud
Gloucestershire GL5 4EP

www.amberley-books.com

British Library Cataloguing in Publication Data.
A catalogue record for this book is available from the British Library.

ISBN 978 1 3981 0662 8 (print)
ISBN 978 1 3981 0663 5 (ebook)

Typesetting by SJmagic DESIGN SERVICES, India.
Printed in Great Britain.

Contents

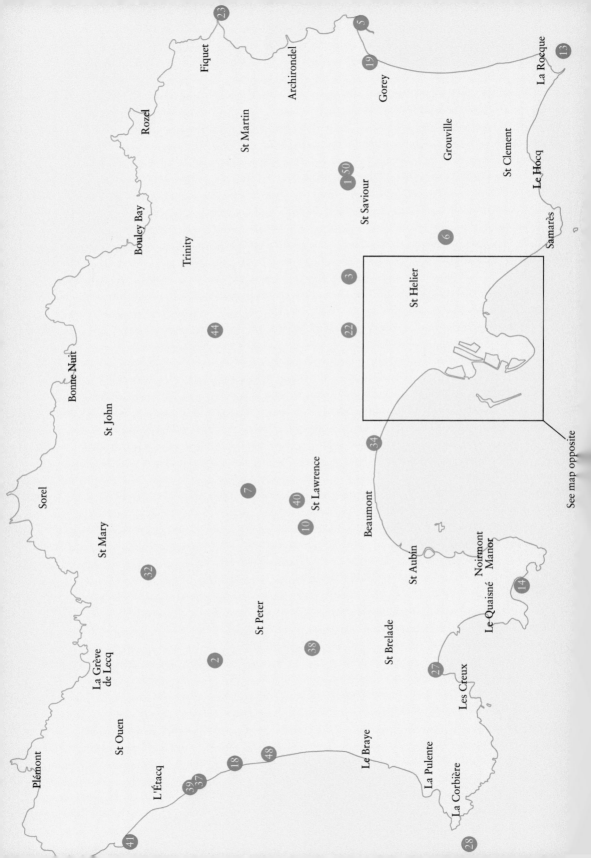

Plémont

St Ouen

La Grève
de Lecq

L'Étacq

41

39 37

18

48

Le Braye

La Pulente

La Corbière

28

St Mary

32

St Peter

2

38

St Brelade

Les Creux

27

Le Quaisné

Noirmont
Manor

14

Sorel

Bonne Nuit

St John

7

40 St Lawrence

10

Beaumont

St Aubin

Rozel

Trinity

Bouley Bay

44

St Martin

Fiquet

23

Archirondel

5

Gorey

19

St Saviour

1 50

3

22

6

St Helier

34

See map opposite

La Rocque

13

Grouville

St Clement

Le Hocq

Samarès

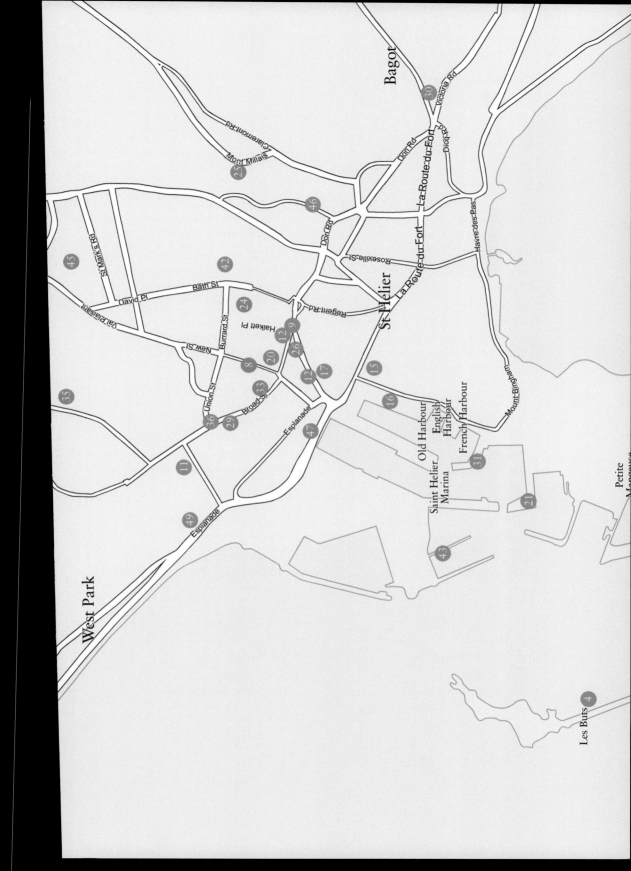

Key

Introduction

The largest of the Channel Islands, Jersey is situated 85 miles from the English coast and 14 miles from France at the closest point. Even though it occupies just 45 square miles, Jersey has an abundance of history and culture, and its physical form and location have shaped much of its story through the centuries. Today, the island is a popular destination for visitors who are attracted by its heritage, local produce, picturesque countryside and stunning coastal scenery, and for locals Jersey is a wonderful place to live.

From prehistory to the twenty-first century, Jersey's inhabitants have left part of themselves via the buildings and structures they created. The Neanderthals, Jersey's earliest arrivals, were not builders, but its later, more settled Neolithic community created many archaeological treasures. These include La Hougue Bie, which today opens a window onto the spiritual practices and rituals of these ancient residents.

Standing guard over Jersey's east coast is medieval Mont Orgueil Castle, which together with many eighteenth-century fortifications, reminds us of conflict with France and Jersey's historic importance to Britain. Churches tell of the island's religious development, with harbours, quays and piers being tangible evidence of Jersey's vibrant maritime trade and heritage. Buildings and structures like schools, shops, monuments and houses reveal more about Jersey's community and the experiences of individuals, while grey concrete bunkers tell of five dark years of enemy occupation during the Second World War. In contrast, the modern buildings that today house such institutions as banks, trust companies and law practices in the island's capital St Helier highlight Jersey's principal twenty-first-century industry: finance.

In this book, local author and Blue Badge Tourist Guide Tracey Radford presents an engaging portrait of fifty of the island's buildings and landmarks. Featuring many eras and a variety of structures and architectural styles, the chosen buildings create a framework for a chronological exploration of Jersey's development, and this framework also allows a fascinating story to be told. The places range from churches to castles, follies to forts and wartime sites to lighthouses. Each building's account will give readers valuable insight into the island's past and its present, and if their interest is really piqued, they can read more about Jersey in Tracey's previous book, *A–Z of Jersey: People, Places and History*.

While this is not the definitive narrative of Jersey, it is an account, with Tracey selecting buildings that she feels reflect Jersey's incredibly rich and diverse story in a multitude of ways. From Neolithic times to the twenty-first century, with themes including war and occupation, culture and community and Jersey's unique relationship with the United Kingdom, this book will engage, fascinate and perhaps surprise its readers and hopefully encourage them to find out more about this beautiful, intriguing and unique little island.

The 50 Buildings

1. La Hougue Bie

Prehistoric Spirituality

To gain understanding of how prehistoric lives were led, archaeologists investigate evidence such as stone tools and animal remains from this time. They also study man-made structures, including one in Jersey that is older than Egypt's pyramids.

La Hougue Bie is a 6,000-year-old passage grave concealed within an earth and rubble mound. Standing around 12 metres high, it was discovered in 1924 during archaeological excavations by the Société Jersiaise. A small aperture on the east side leads into a long passage which opens into a chamber constructed from upright granite slabs, topped with a massive capstone.

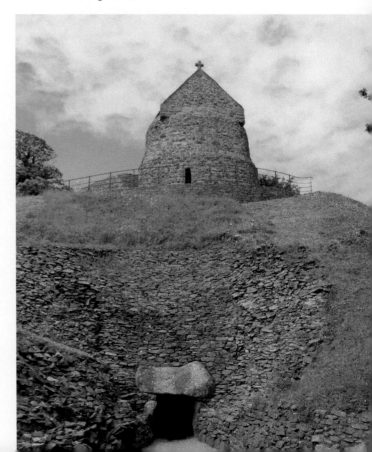

Entrance to the passage grave, La Hougue Bie. (© Simon Radford)

Interpretation of La Hougue Bie's physical form and contents offers insight into prehistoric life and beliefs. For instance, the easterly orientation of the passage captures the Spring and Autumn Equinoxes' rising sun, and it guides the light into the structure's focal point, the chamber. This suggests connections with seasons and harvest, which were crucial for Neolithic people as they established settlements and became reliant on agriculture and the domestication of animals.

The passage may not just be a way into the main chamber though. Measuring only 1 metre in height, it could have been designed to engender a sense of awe because those entering have to bend into what may be considered a reverential posture. Also, the chamber's limited capacity could have created a hierarchy within this early society, with only the elite able to access the chamber.

Items found here offer possible explanations of La Hougue Bie's function. Human bones suggest a burial chamber, while scorched pottery vessels may have been used to burn incense, thus implying a spiritual or ceremonial purpose. The granite slabs, some of which weigh 20 tons, would have required huge manpower to move them from quarries to the site. Does this mean that those involved in this undertaking were motivated by fear of a ruling elite or by belief in a supernatural being? It is impossible to know, but La Hougue Bie is valuable in offering plausible theories.

La Hougue Bie's chamber. (© Simon Radford)

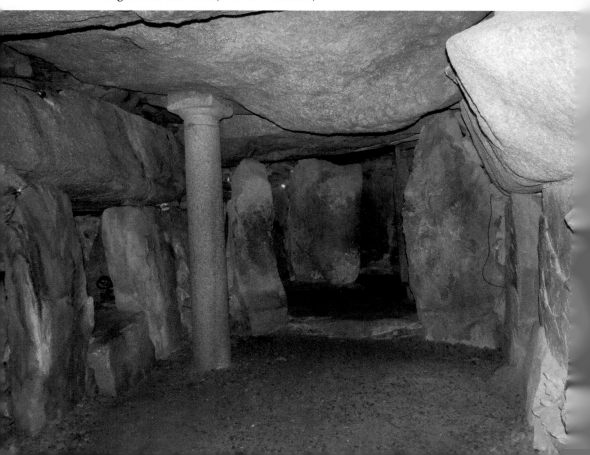

2. St Ouen's Manor

Heroes and Heroines, Tradition and Tragedy

Many Jersey manor houses are residences of a *Seigneur* (like a lord of the manor), who once enjoyed a number of rights including having leave to sentence tenants to death. Happily, this is no longer the case!

One island manor has remained in the same family for around 1,000 years and as such has no title deeds. St Ouen's Manor is the home of the Seigneur of St Ouen and the de Carteret family, and stands in beautiful surroundings with its chapel, woods and ponds providing the perfect setting for this historic property. Whilst the house is a private home extended over the centuries, the manor's granite exterior, with its gargoyles, stained-glass windows and family crest engravings, can be enjoyed when the grounds occasionally open to the public.

The manor is linked to many courageous individuals including Philippe de Carteret's wife Margaret Harliston, who sailed to England and rode post-haste to beg King Henry VII's intervention when Philippe was wrongly imprisoned in the 1490s. Margaret's actions helped persuade Henry to order Philippe's release.

The manor and de Carteret family have other royal connections, with Sir George Carteret acknowledged by King Charles II for his support during the English Civil War. George retained Jersey as a Royalist stronghold until the island was forced to

East aspect of St Ouen's Manor. (© Barney De La Cloche)

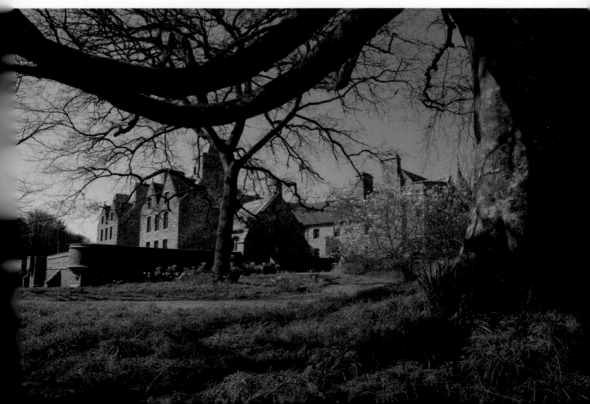

surrender to Parliamentary forces in 1651. For this loyalty, George was gifted land in America, known today as New Jersey.

The manor has not avoided tragedy though. In 1940, Frenchman Francois Scornet escaped German-occupied France and set sail for England to join Free French forces. However, he made a fatal error by landing on Jersey's sister island Guernsey, having mistaken it for the Isle of Wight. Arrested by occupying German troops, Francois was transferred to Jersey and executed by firing squad in the manor's grounds. A terrible event now marked by a simple stone.

Although the history of the manor is undoubtedly fascinating, it remains first and foremost a family home. Nevertheless, from its Great Hall, medieval towers and historic artefacts, the manor is an important part of Jersey's yesterday and today.

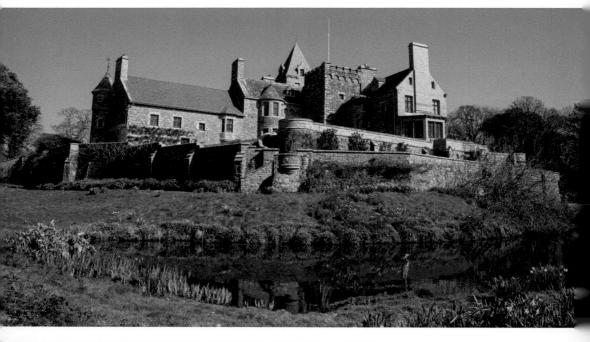

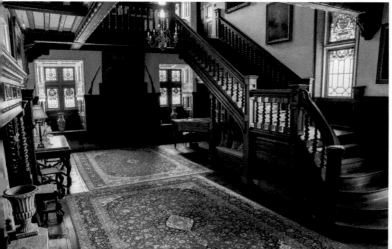

Above: West aspect of St Ouen's Manor. (© Barney De La Cloche)

Left: The Great Hall, St Ouen's Manor. (© Barney De La Cloche)

3. St Saviour's Church

St Sauveur de L'Epine

The island's parish churches have been central to life for centuries and the earliest parts of St Saviour's parish church date from around the eleventh century. Its physical form has evolved over time with renovation works occurring, particularly in the fifteenth century, and today's church, with its buttresses, tower and arcades, is a complex reflection of Jersey's religious development.

The church also goes by the name of St Sauveur de L'Epine, with *L'Epine* meaning 'thorn'. This name could be a reference to the holy thorn tree of Glastonbury, said to have grown from Joseph of Arimathea's staff, or it may be linked to the thorn crown placed on Jesus Christ's head at his crucifixion.

In the cemetery, gravestones allow a glimpse of lives lived. While each provides a focus for the deceased's loved ones, one grave attracts people from around the globe. A white marble bust marks the resting place of a woman who, in the late Victorian and Edwardian eras, both scandalised and fascinated the world. Emilie

The parish church of St Saviour. (© Simon Radford)

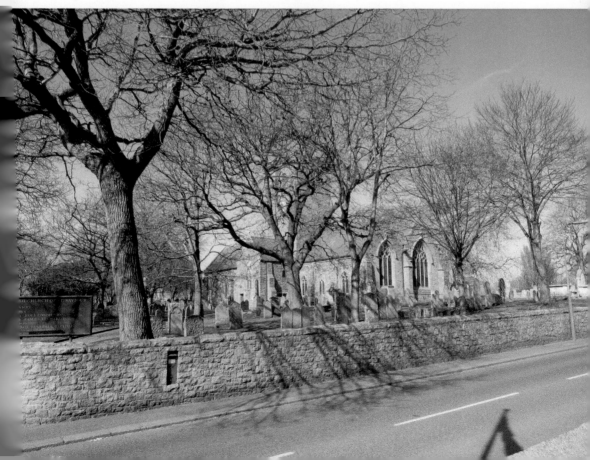

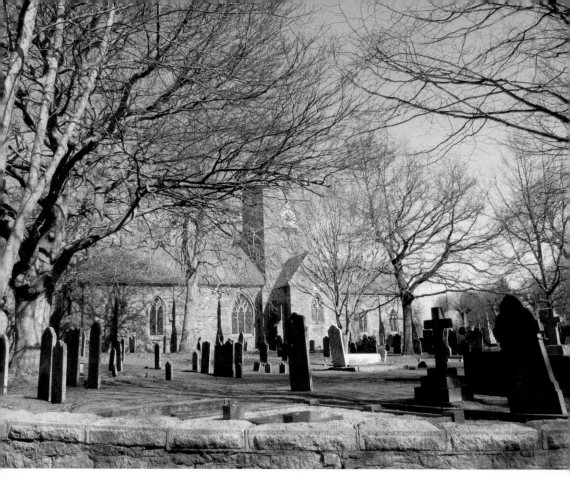

South aspect of St Saviour's. (© Simon Radford)

Charlotte Le Breton, the beautiful and bright daughter of the Dean of Jersey, was born in 1853 and brought up in the rectory near the church. Emilie, or Lillie Langtry as she is more commonly known, achieved fame and fortune through marriage, a shrewd business sense, her acting career and liaisons with high-profile gentlemen, including a future king. She died in 1929 and was buried in the Le Breton family grave.

Dark times are unfortunately associated with the church, notably the St Saviour wireless case during the German occupation of Jersey. Radio possession was prohibited by the occupying force; however, Clifford Cohu, the rector of St Saviour, and parishioners Joseph Tierney, Arthur Dimmery and John Nicolle defied this ruling by hiding a wireless and listening to and circulating news from illicit BBC broadcasts. Sadly, their activity was discovered by the Germans and all four men perished in German prisons and camps.

Notwithstanding this tragedy though, like other parish churches in Jersey, St Saviour's Church is a tranquil place that provides a peaceful location for reflection, community and worship.

4. The Hermitage at Elizabeth Castle

Christianity Arrives

While Elizabeth Castle was built to defend, one structure here was created for a very different reason. Accessed by steep steps, the twelfth-century Hermitage was built over a rocky outcrop where St Helier is said to have lived in the sixth century. Helier was one of the first evangelising holy men to bring Christianity to Jersey, and it's thought that having arrived, his need to become closer to God prompted him to live in isolation on this exposed crag.

Legend says that Helier's peace was sometimes disrupted by Vikings, who roamed the seas attacking vulnerable communities like Jersey's, and several theories exist about Helier's response to these incursions. One is that Helier lit fires to lure Viking ships towards the coast's lethal rocks, while another says that Helier would warn islanders of imminent attacks. Whatever his actions, legend also has it that these invaders exacted revenge by beheading Helier in AD 555, but that the decapitated Helier picked up his head and advanced towards his attackers, who, not surprisingly, fled in terror!

Today, visitors and worshippers can join a pilgrimage for St Helier. This progresses from the parish church of St Helier to the Hermitage on 16 July each year.

Below left: The twelfth-century Hermitage at Elizabeth Castle. (© Simon Radford)

Below right: Looking into the Hermitage at Elizabeth Castle. (© Simon Radford)

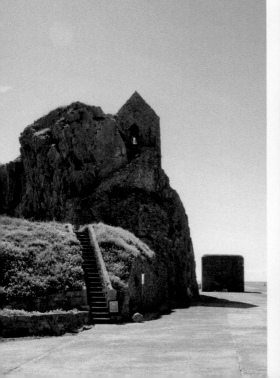 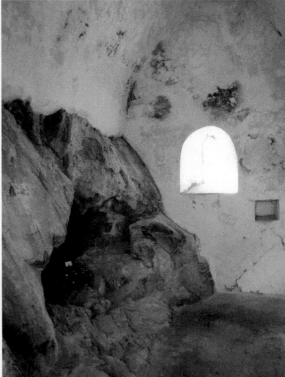

5. Mont Orgueil Castle

English Stronghold, Prison and German Defensive Position

Mont Orgueil Castle, one of Jersey's most iconic buildings, has dominated the island's east coast since the 1200s and was built following King John of England's loss of Normandy to the French king. With Jersey remaining loyal to England, the fortress's primary function was to defend against French attack and provide a strategic military base for England during the ensuing centuries of conflict with France, just 14 miles away.

Mont Orgueil's design was based on the concentric model with a series of defensive walls radiating from and around the centre. However, the castle's form has been modified to some extent, with the different circumstances of various times leaving their mark on this extraordinary structure. The sixteenth-century Grand Battery, for instance, was built for artillery when medieval weapons, such as bows and arrows, were superseded by cannon and musket. Also, during their Second World War occupation of Jersey, the Germans added defensive structures to the castle, disguised as medieval towers.

Mont Orgueil was a Royalist base during the English Civil War (1642–1651), and islanders generally remained loyal to King Charles I. However, once Oliver Cromwell's hostile Parliamentarian army invaded Jersey in 1651, Mont Orgueil and Elizabeth Castle became the Royalists' final lines of defence, which ultimately crumbled under the enemy's onslaught.

Mont Orgueil was also a prison until the seventeenth century, and today visitors can see the less than luxurious cells that accommodated some of the

Mont Orgueil Castle and Gorey Harbour. (© Barney De La Cloche)

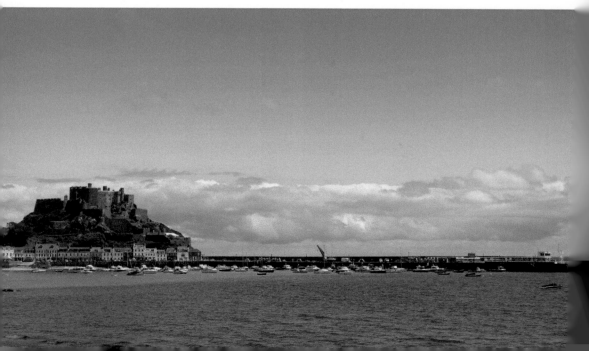

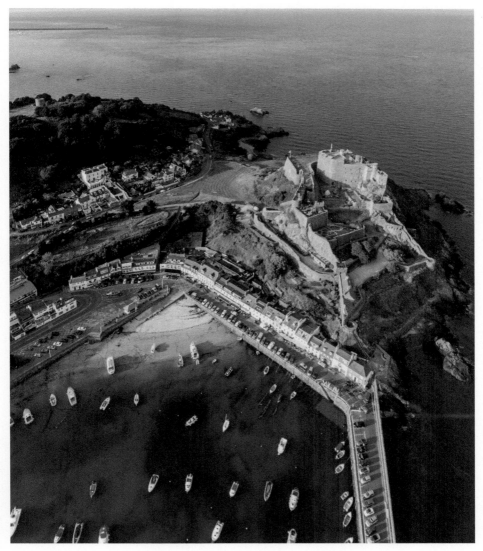

Aerial view of Mont Orgueil Castle and Gorey Harbour. (Courtesy of Visit Jersey)

prisoners incarcerated within. Historic figures who served time in these dank confines included William Prynne, the Puritan critic of Charles I and his Catholic queen, Henrietta-Maria. Several jurors who sentenced this king to death were also imprisoned here following the restoration of the monarchy and the ascension of Charles II to the throne in 1660.

Today, Mont Orgueil remains relevant for young and old as its tours and events inform, entertain and engage. Whether you want to get married here, watch a Shakespearian play, go ghost hunting or just enjoy a great view of France in the distance, head to this castle – it pretty much has it all.

6. Longueville Manor

History and Hotel Excellence

Longueville Manor is a historic house, which nowadays is a Relais & Châteaux luxury hotel. Purchased by Sidney and Edith Lewis in 1949, this former home has been transformed into one of the Channel Island's premier hotels by them and subsequent generations of their family. The manor's story is long, and the building gives tantalising glimpses into the life and times of its occupants through the years.

The first mention of a manor here was found in documents dating from 1332, although it is unclear how much of that original building survives. Fortunately, it is possible to establish some of the manor's past by focusing on its architectural features and embellishments. These include the arch that surrounds the manor's entrance, which local historian Joan Stevens described as 'the largest and most ornamental of all [the] round arches in the island'. The arms of Hostes Nicolle Bailiff of Jersey 1560–64, which sits above the arch, led Ms Stevens to date it to the 1550s or possibly earlier.

Attached to the rear of the building is a tower whose height was increased by approximately 9 metres by the manor's nineteenth-century owner, Revd W. B. Bateman. He was also responsible for completing the dining room's oak panelling, begun in the 1660s by Benjamin La Cloche, and for landscaping a significant amount of the manor's beautiful grounds.

Longueville Manor. (Courtesy of Visit Jersey)

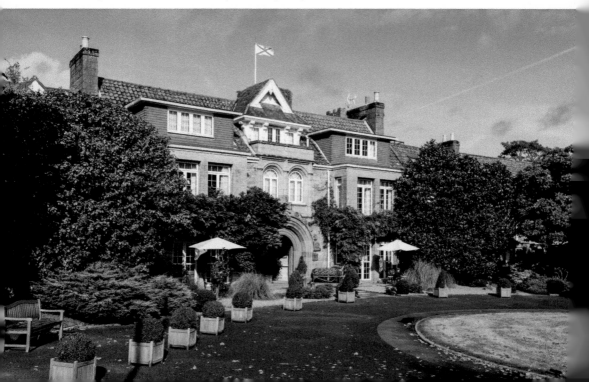

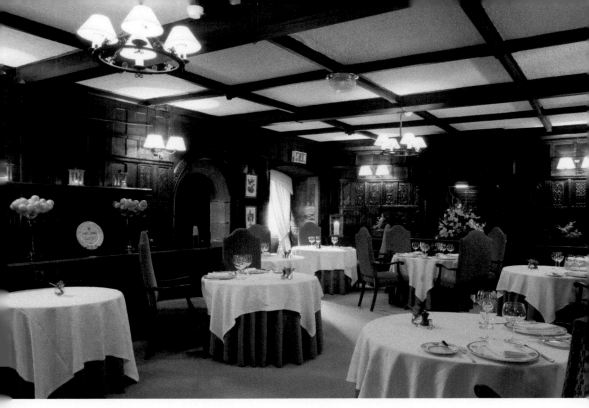

The Oak Room restaurant, Longueville Manor. (Courtesy of Malcolm Lewis)

Like many larger island houses, the manor was appropriated by German troops and used as officers' quarters during their occupation of Jersey in the Second World War. Following liberation, the manor was discovered to be in a poor state, a condition that was eventually rectified by the Lewis once they became its owners.

Sidney and Edith's grandson Malcolm and his wife Patricia are the present owners and whilst they continue to develop their business, they have retained the manor's historic integrity. This is a Jersey treasure, and Longueville Manor's wisteria-framed façade, cosy sitting rooms, authentic panelled dining room, renowned cuisine and, essentially, the hotel's extensive wine cellar, together ensure a memorable visit.

7. Morel Farm

Jersey's Agricultural Heritage

The island's farming practices can be traced back at least 8,000 years to when man began to settle and domesticate animals in Jersey, and agriculture has since become a significant part of Jersey's economy. Tucked away in the St Lawrence countryside is Morel Farm, a collection of buildings that are part of this rich farming heritage.

The earliest parts of the farm are believed to date from the seventeenth century, with various structures and buildings added over the years. The main house and outbuildings are set around a cobbled courtyard, which is an uncommon feature

for island farms to have. Granite is the predominant building material and the overriding impression here is of traditional Jersey architecture, created from a local material that is both attractive and functional.

Various crops have dominated Jersey's agriculture and in the twenty-first century, the principal crop is the Jersey Royal potato, worth around £30 million per year. This delicious little spud is usually available from March until July and is best served lightly boiled until tender and dripping with creamy Jersey butter. However, one of Morel Farm's buildings, the *pressoir,* is a reminder of another crop that was once extremely lucrative, and which is enjoying a resurgence today. During the seventeenth and eighteenth centuries, cider apples were big business and research in the 1950s by the Société Jersiaise suggests that orchards covered as much as 15.5 per cent of Jersey at this time. It was in the farm's *pressoir* building that the circular apple crusher was situated, and one can picture a pony plodding around the structure attached to the contraption's crushing arm. This action forced the apples to yield their juice and pulp, and the smell from this must have been incredibly intense.

Today, this collection of historic buildings is owned by the National Trust of Jersey and several of the structures are being refurbished as visitor accommodation, including the Farmhouse and Bakehouse. This will mean that both visitors and locals can experience Jersey's unique agricultural heritage for themselves in this beautiful rural setting. If you happen to stroll by, you can also enjoy a view of the buildings and courtyard through the double arches of the entrance.

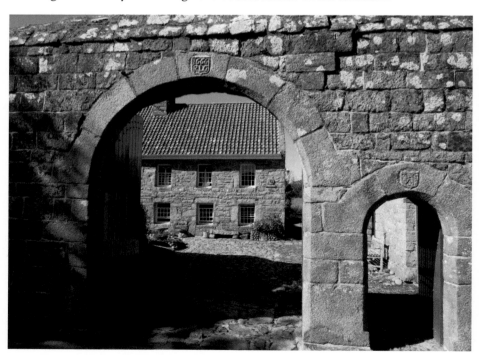

Morel Farm, seen through its dual archway. (© Simon Radford)

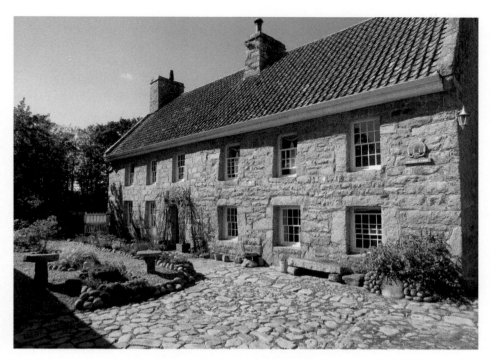

The courtyard and house of Morel Farm. (© Simon Radford)

8. No. 16 New Street, St Helier

Georgian Proportion, Regency Sophistication and Victorian Respectability

St Helier is an architectural gem with its buildings reflecting the town's periods of development and growth. One of these is No. 16 New Street, a property constructed in the 1730s that has been a home, a gentlemen's club and even a curtain-making workshop. Neglected and crumbling from the 1970s, the property was brought back to life by the National Trust of Jersey in the early 2000s following a generous donation of £1 million. A programme of extraordinary refurbishment and repair has led to its rebirth and the house now helps visitors experience what life was like for St Helier's more affluent residents in the eighteenth and nineteenth centuries.

The property was built during the reign of King George II, a time of increasing Jersey trade and expansion of St Helier's harbours. These factors contributed to the town's evolution and No. 16 New Street was one of many houses built for those who required homes near the island's commercial hub.

No. 16 New Street's early Georgian features include uncomplicated and balanced lines, and walls that were limewashed and grooved to create faux masonry. This was intended to disguise the stone below, thus creating an image of prosperity and refinement. Ironically, the exteriors of similar structures from this

period in St Helier have been stripped back to reveal the original granite below, suiting modern preferences for a more natural aesthetic.

During the Regency period (1811–20), the house was altered to reflect this era's taste for classical elegance and a Doric column surround was added to the front door. Additional modifications included a reduction in roof size and installation of new windows. The incumbent cook was not left out of the modernisations either and the kitchen boasts the up-to-date Regency conveniences of a range and charcoal stove.

During the later years of the nineteenth century, No. 16 New Street served various purposes at different times. However, following its twenty-first-century transformation, the property has established itself as an outstanding and fascinating part of Jersey's cultural heritage.

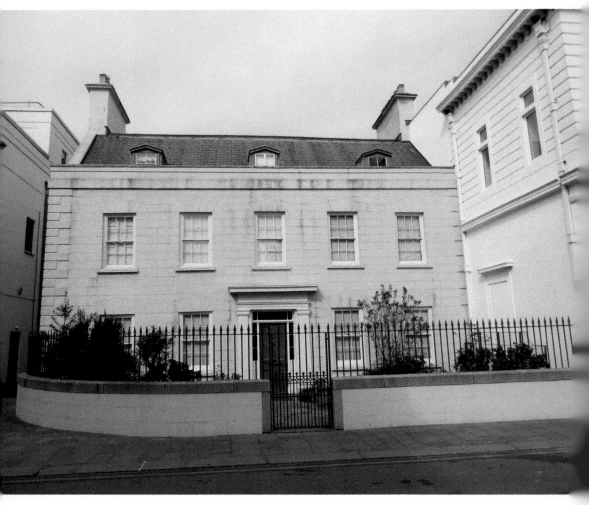

No. 16 New Street. (© Simon Radford)

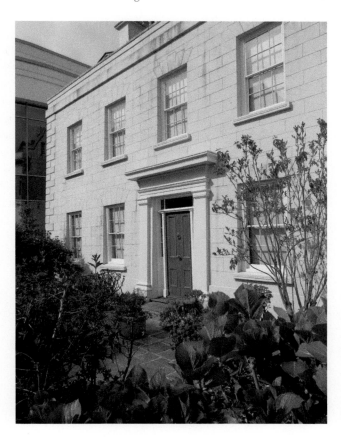

No. 16 New Street
and garden. (© Simon
Radford)

9. The Old Chamber of Commerce Building

An Island of Enterprise and Enlightened Thinking

It could be said that what Jersey lacks in size has been, and still is, balanced by the creative, forward-thinking and innovative qualities of its population. For example, the British Isle's first lending library was opened here in the 1740s and Jersey currently has a flourishing finance industry and one of the world's fastest broadband services.

A physical manifestation of this enterprising spirit is located in St Helier's Royal Square. Owned by the Hemery family in the eighteenth and early nineteenth centuries, this four-storey building became the headquarters of the English-speaking world's first Chamber of Commerce in 1835.

The Chamber's founding in 1768 coincided with the evolution of a middle class in both the United Kingdom and Jersey. Made up of professional men like clergymen, doctors and merchants, this group would have sought to represent island business, to be involved in policymaking and to achieve 'independence from ... landed wealth and power'.

From the eighteenth century, Jersey's merchant shipping fleet was involved in a vigorous global trade that saw local ships transporting cod caught by Jersey fishermen in Newfoundland to many destinations, as well as bringing home exotic items like tropical fruits and mahogany. Jersey's merchants were determined to protect these lucrative trading interests and the Chamber of Commerce was seen as a means of achieving this. Consequently, over the years the Chamber has been involved in various projects to support local business and the island's workers. Initiatives have included spurring an increase in wages for skilled craftsmen working onboard merchant ships in the 1780s, and in the mid-nineteenth century, driving expansion of St Helier's harbour, Jersey's centre of shipping and trade.

While Jersey's Chamber moved to different premises in 2001, it remains active in protecting the various elements of the island's business community. Additionally, it supports local charities, hosts presentations and events for its members, and is 'the largest independent business membership organisation in Jersey, representing businesses of all sizes and sectors'.

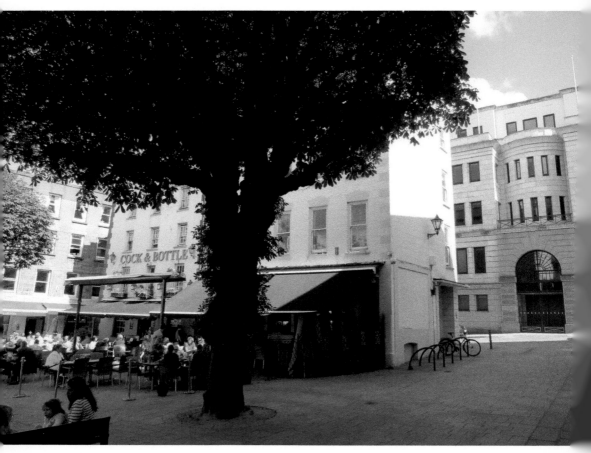

The old Chamber of Commerce building, from the Royal Square. (© Simon Radford)

The old Chamber
of Commerce
building from
Halkett Place.
(© Simon Radford)

10. Le Moulin de Quétivel

Water-powered Industry

From medieval times, watermills and windmills have been common features of
Jersey's landscape, and they performed various tasks including grinding wheat
and cleaning impurities from sheep's wool, a process called fulling. The natural
power sources driving these machines were streams that flowed through the
island's valleys and wind, of which there can sometimes be an abundance of on
the island!

Built on the site of a fourteenth-century watermill and one of nine Crown Mills
belonging to the English monarch, eighteenth-century Le Moulin de Quétivel is
Jersey's only remaining working mill. Fixed to one side of the granite building is a
large waterwheel, which scoops up water from the adjacent stream, and the power
generated by this action drives the complex machinery in the mill's interior spaces.

The National Trust of Jersey runs and manages the mill, and its doors are regularly opened to the public. Inside, visitors can observe the milling process with interpretation via information boards, staff and volunteers. The millstones grind, wheels turn, chains and pulleys swing and collectively they work to produce flour, the universal food staple of generations.

Over time, the mill has experienced mixed fortunes. With little of the machinery remaining by the Second World War, the mill was recommissioned by the German army during its occupation of Jersey in an attempt to supplement dwindling food supplies. However, following liberation in 1945, the mill fell into disrepair and was damaged further by fire in 1969, but fortunately it was rejuvenated by the National Trust of Jersey in 1979.

The mill is set in lush water meadows at the southerly end of St Peter's Valley and while there is some visitor parking available outside, parking further up the valley and enjoying a walk to the mill through the tranquil woods is highly recommended. If you come to the mill this way, look out for Jersey cows, sheep and goats grazing in the verdant valley and if you look up, you might spot a cheeky red squirrel darting from branch to branch among the trees.

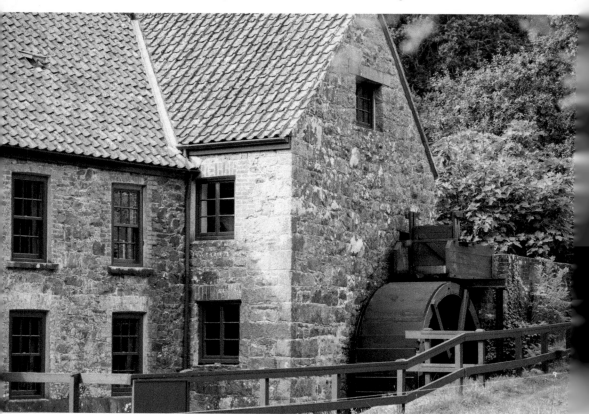

Moulin de Quétivel and its water-driven wheel. (Courtesy of Visit Jersey)

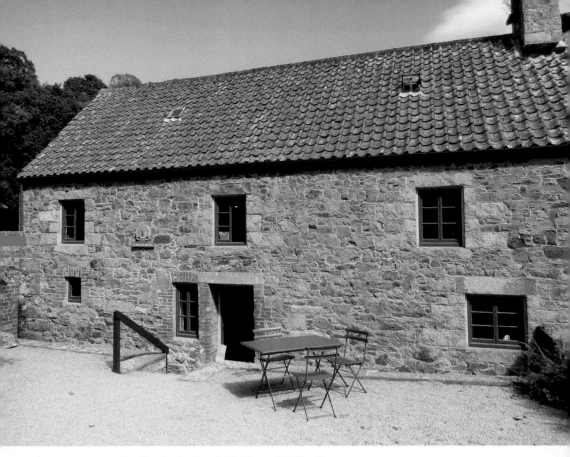

The entrance to Moulin de Quétivel. (© Simon Radford)

11. The General Hospital

Paupers and Patients

During the eighteenth century, the number of hospitals increased throughout Europe. However, clear your mind of twenty-first-century expectations of a purely medical environment and instead imagine an institution that, although there to treat the sick, also housed orphans, the destitute and those whose morality was considered questionable. In the eighteenth century and even into the nineteenth century, hospitals were universally considered as 'places for the cure of the soul as well as the body', where an appropriate diet was a go-to treatment, and this was no different in Jersey.

In an era of enlightened philanthropy, Jersey's hospital was the result of a wealthy widow's significant bequest and her instruction to build a place to accommodate 'Poore widows and Fatherlaise Childrane', essentially a poorhouse. This woman was Marie Bartlett and while she died in 1741, it wasn't until the 1790s that the building was utilised to fulfil Marie's wish.

Initially the completed building in St Helier's Gloucester Street became a barracks for British servicemen stationed in Jersey, a constant reminder of the continuing threat from France. Indeed, soldiers quartered in the building fought in the Battle of Jersey in 1781, helping to oust invading French troops.

Nevertheless, Marie's dream did eventually become a reality and a diverse range of occupants with differing needs became hospital residents. Abandoned and orphaned children, prostitutes, vagrants, alcoholics and the mentally ill, together with the physically incapacitated, all came together to share this imposing space.

A devastating fire in 1859 caused significant damage, but over time the hospital recovered and today offers a wide range of healthcare. From operating theatres, an intensive-care ward and a maternity unit, to a radiography and outpatient department, patients now have very different experiences than those who came through the hospital's doors over 200 years ago.

There are plans to construct a new hospital, but at the time of writing this account, a site has yet to be decided upon. So for the moment, this General Hospital continues to meet the various medical needs of islanders.

The General Hospital's façade. (© Simon Radford)

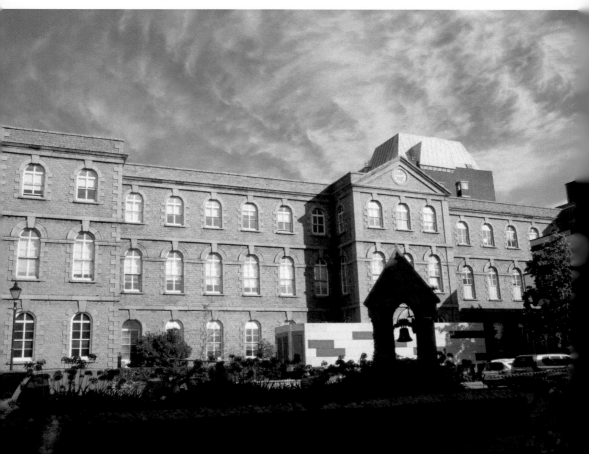

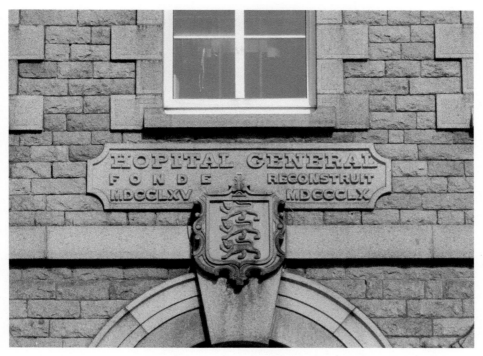

The General Hospital was founded in 1765 and rebuilt in 1860. (© Simon Radford)

12. Historic Pubs of St Helier

Heritage ... on Tap

St Helier has many pubs but don't think that islanders exist in a permanent state of inebriation; we are just a sociable bunch! Some are historic hostelries whose walls and bars are part of Jersey's narrative, and as it's impossible to single-out one pub, let's go on a virtual pub crawl to find out about some of them.

Two of St Helier's oldest watering holes are in the Royal Square and history simply oozes from them. Originally private homes, on 6 January 1781, the Cock and Bottle and Peirson buildings were front-line in a bloody battle. This was fought in and around the square between invading French troops and British soldiers supported by Jersey's Militia. The Peirson was home to Doctor Lerrier and he was called upon to tend a casualty of the battle, the mortally wounded French leader, Baron de Rullecourt. Like his French counterpart, the British commander Major Francis Peirson also perished in the battle, slain near the pub that today bears his name.

Not far away is the Lamplighter, a pub identifiable by its unique exterior. Swags of colourful fruit compete for attention with Corinthian columns and cherubs.

Sitting on top of this magnificent display is the figure of Britannia, complete with her trident and Union flag shield, which was created by John Giffard, who carved the first 'devil' at Devil's Hole.

Our final stop is the Prince of Wales, which is tucked away in Hilgrove Street, also known as French Lane. This pub has many architectural delights, notably a Georgian fanlight, and it's well known for who once served behind the bar. Standing on a box due to her diminutive stature, Mrs Drelaud made up for her lack of height with a fearsome reputation that during the island's German occupation, allegedly terrified the most battle-hardened German soldiers who dared order a drink here!

These historic pubs are traditional inns with twisting staircases, beams and period features. While each has its own character and story to tell, you can be assured of a warm welcome and some lively discussion with townsfolk who are proud to call these pubs their 'local'.

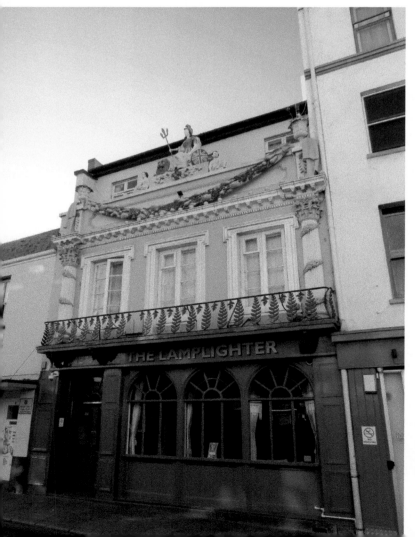

The glorious frontage of the Lamplighter historic pub. (© Simon Radford)

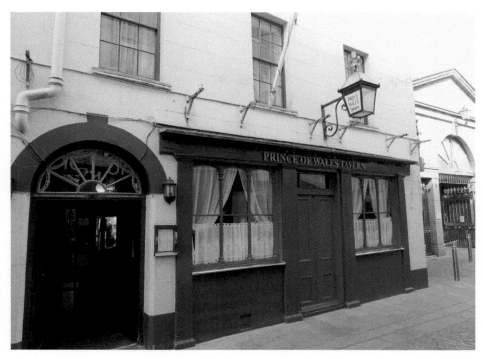

Above: The Prince of Wales historic pub. (© Simon Radford)

Below: The Peirson and Cock & Bottle historic pubs. (© Simon Radford)

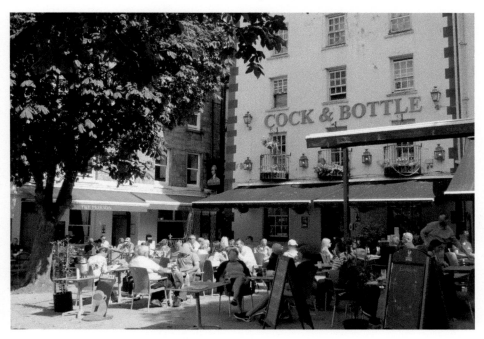

13. Seymour Tower

Island Defence Surrounded by a Marine Treasure Trove

Looking out to sea from the island's south-east coast, it's impossible to miss the solitary tower standing on the horizon. This is Seymour Tower, built in 1782, a year after an unsuccessful invasion attempt by France. Seymour Tower's presence offers insight into Britain's response to this event and its ongoing anxiety about French invasion, not just of Jersey but also its other domestic and overseas' domains.

In a plan initiated by Jersey's Governor, General Henry Seymour Conway, twenty-three coastal defence towers were constructed between 1778 and 1801, with Seymour Tower being one of these. Twenty-two were round in form, but Seymour Tower is square and at 2 kilometres from land, the furthest offshore.

The granite tower was built on l'Avarison islet and an additional gun battery at its base highlights its importance as an offshore defensive position. The tower was also part of an early warning system that used lights to alert troops based in Jersey of imminent French attack.

The tower's interior is accessed on the first floor by a ladder that would have been raised if the tower was attacked, and authentic features include a fireplace, loopholes and windows. Reports from the 1840s note the presence of two 32 pounder cannons and that the lower-level magazines could accommodate twenty-five barrels of gunpowder.

While Seymour Tower is an outstanding element of Jersey's military history, it is also located within an area noted for its remarkable biodiversity that has

Seymour Tower at low tide. (Courtesy of Visit Jersey)

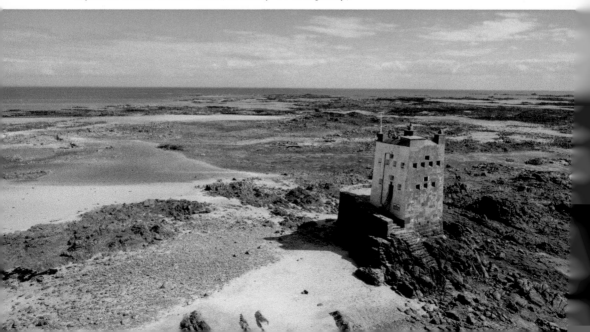

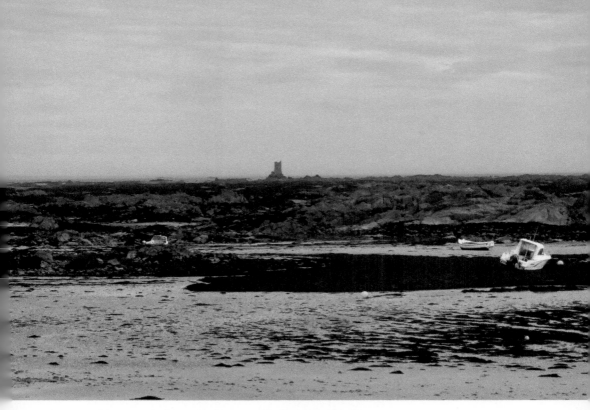

Seymour Tower and glimpses of France. (© Simon Radford)

been designated as a Ramsar site. This means it is recognised as a 'wetland of importance' and initiatives are consequently in place to conserve and protect it. This area can be investigated on very low tides, however, it is highly recommended that this is done with a qualified guide, as the tides rise extremely quickly here, making this a potentially dangerous environment for unsuspecting explorers.

If it's adventure you want, then stay overnight at the tower (with a guide). It has basic accommodation and cooking facilities, and guests must bring all their supplies. Be warned though, on the walk back to shore, you will be carrying all your waste – yes all of it!

14. Portelet Tower

Tower or Tomb?

Scenic Portelet Bay lies at the foot of cliffs and access is via an impressive number of steps. This provides an excellent workout and ensures that the beach is never too busy.

Dominating this pretty bay is Portelet Tower, which is located on an islet close to shore called *Ile au Guerdain*. However, despite its 'official' title, you might also hear locals refer to the tower as Janvrin's Tomb, but more of that later.

Portelet Tower, Ile au Guerdain and Portelet Bay. (Courtesy of Visit Jersey)

Portelet Tower, built in 1808, was one of several Martello towers and nearly thirty round towers, constructed to defend against French attack in the late 1700s and early 1800s. The notion of Janvrin's Tomb arose from a tragedy occurring nearly 100 years before the tower was built, when in 1721 Captain Philippe Janvrin and crew of *The Esther* were returning to Jersey from France where plague was raging. On arrival in Jersey, the ship was quarantined in Belcroute Bay, but during this isolation Philippe died, and the authorities insisted that his body be interred on *Ile au Guerdain* rather than onshore, hence Janvrin's Tomb. The body was later reburied on mainland Jersey, and the tale has subsequently become something of a local legend.

15. Fort Regent

A Tale of War and Peace

France and Jersey have had a complex, often antagonistic relationship, however today connections are usually *très amical*. Nevertheless, reminders of this historic enmity can be found in the island's many defensive structures.

In 1781, French attack led to the Battle of Jersey, which resulted in the comprehensive defeat of the French army by British troops in the Royal Square.

While the invasion was unsuccessful, the continuing French threat drove an increase in the number of island fortifications.

Napoleon's European dominance in the early nineteenth century heightened concern for the island's safety and in 1806 the foundation stone of a new stronghold was laid. Located on Le Mont de la Ville or the Town Hill, overlooking St Helier and its vital harbours, Fort Regent was completed in 1814 and named after the Prince Regent, later King George IV. With its robust walls, multiple bastions and ramparts, the fort remains an imposing edifice whose guns were ironically never fired against the French. Following the defeat of Napoleon's army by Britain and its allies at the Battle of Waterloo in 1815, hostilities with France ceased, although the fort remained a British garrison until the 1920s. It briefly reacquired defensive status between 1940 and 1945, when Jersey's German occupiers installed anti-aircraft guns here.

A signal station, one of several which provided island-wide communication using the language of flags, is also located at Fort Regent. The station's mast now displays a ball and cone to alert sailors and residents when bad weather approaches, while the T flag, an inverted tricolour, flies when high tides of over 11 metres occur. The mast is also dressed in appropriate flags to mark significant occasions such as the British monarch's birthday.

In the 1960s and 1970s Fort Regent transformed into a leisure centre built around the fort's original framework, with a distinctive domed white roof added

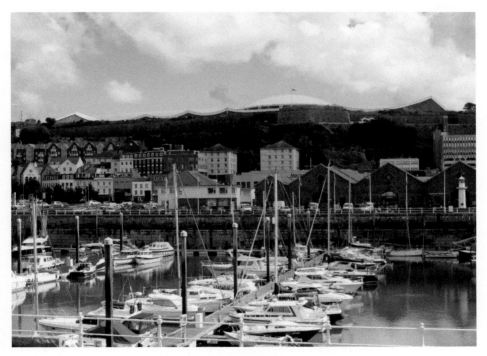

Fort Regent on Mont de la Ville. (© Simon Radford)

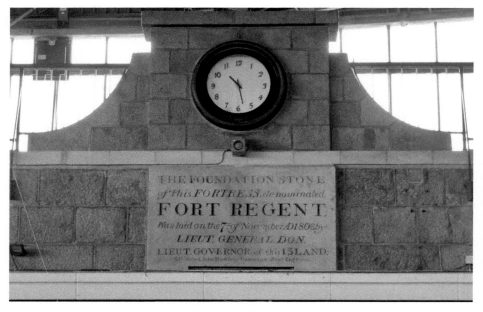

Fort Regent's foundation stone. (© Simon Radford)

to this. The fort now hosts concerts, sporting events and houses a gym, but despite all these changes, you can still experience the original structure by walking the ramparts and exploring many parts of this once formidable fortress.

16. Le Quai aux Marchands

Commercial Buildings

As an island, the sea has unsurprisingly shaped and impacted Jersey in many ways over time, and this includes its seaborne trade. A robust infrastructure is necessary to sustain this vital activity, but in the eighteenth century existing facilities began to struggle as Jersey's maritime commerce flourished. Of particular concern was the landing of goods in St Aubin's harbour, as St Helier had no suitable places to do so. Once loaded onto carts in St Aubin, goods were dragged across the sands of St Aubin's Bay to St Helier as before the nineteenth century, proper roads in the island were conspicuous by their absence. This must have been a gruelling and lengthy trek, and something had to be done.

Although some improvements to St Helier's harbour were made in the late 1700s, delays to further development drove Jersey's merchants to take matters into their own hands. In 1814 they initiated and funded the construction of a new wharf that became known as Le Quai aux Marchands, or the Merchants' Quay. This was lined with their offices and warehouses, collectively called Commercial

Buildings. But while merchants were allowed to build in this location, the authorities restricted the height of these structures so that the cannon located above at Fort Regent had a clear line of fire across the harbour.

Many of the original buildings remain, although some newer structures now interrupt the early nineteenth-century architecture. These replaced buildings destroyed by the German's pre-occupation bombing of the island on 28 June 1940, an event that resulted in the tragic deaths of nine civilians.

Commercial Buildings house businesses, residential accommodation and Normans, a company offering various services such as supplying materials to the building trade, which has a history dating back to the 1840s. This building is easily identifiable by the distinctive mural adorning its exterior. The mural, featuring several figures gathered together, celebrates Jersey's immigrant communities and their 'contribution to island life'.

Le Quai aux Marchands looking west. (© Simon Radford)

Le Quai aux Marchands. (© Simon Radford)

17. The Merchant's House and Jersey Museum

Jersey History and Lives Lived

Jersey has a number of superb museums and heritage sites within its 45-square mile area and visiting them is an excellent way to gain insight into the island's considerable historical narrative. One of these is Jersey Museum, where over several floors, visitors can experience 250,000 years of island life and meet many of Jersey's most memorable characters.

Located off St Helier's Weighbridge area, the entrance is accessed under a granite arch that marks the foundation in 1873 of the Société Jersiaise whose premises adjoin the Pier Road side of the museum buildings. The museum itself is a pleasing combination of old and new. It was created from an early nineteenth-century home, the Merchant's House, and a modern structure built in the 1990s, whose thoughtful design perfectly complements its historic partner.

The Merchant's House, or No. 9 Pier Road, was built by wealthy merchant Philippe Nicolle around 1816, and was home for him and his family, as well as his place of work. The family's realm was the upper floors while Philippe conducted

his business on the ground floor. Original features to look out for are stylish Regency fan lights, grand marble columns and imposing mahogany doors, all of which served to demonstrate Philippe's wealth and eminent position in society to those who visited the house on business or for social occasions. Today the house is curated to tell the story of nineteenth-century occupants, the Ginestets, whose circumstances were less fortunate than Philippe's. With its flickering gas lights, magnificent mahogany staircase and beautifully dressed rooms, those who enter the house are transported back to Victorian Jersey.

The museum is one of Jersey Heritage's sites, which also include Mont Orgueil, Elizabeth Castle and the nearby Maritime Museum, and Jersey Heritage rightly calls itself 'Gardien of [the] Island story'. Its employees are supported by an enthusiastic team of volunteers who take on roles such as tour guides and visitor hosts, as well as helping to maintain its sites and array of historical objects and art.

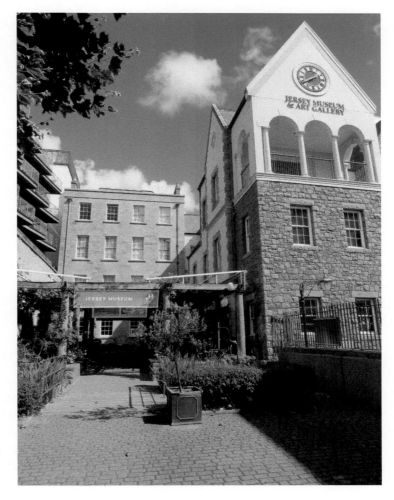

The Merchant's House and Jersey Museum. (© Simon Radford)

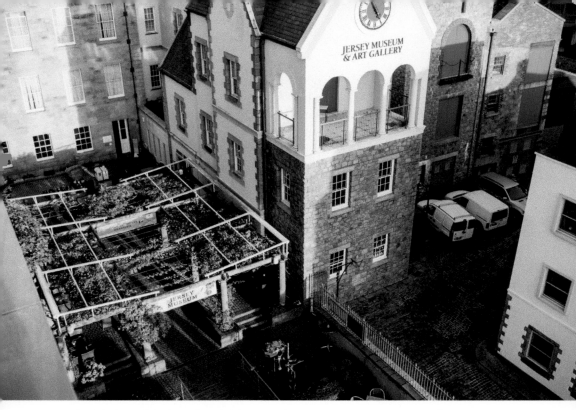

Aerial view of the Merchant's House and Jersey Museum. (Courtesy of Visit Jersey)

18. Kempt Tower

A Western Defence Surrounded by Natural Beauty

Until the nineteenth century, the threat of invasion generated a persistent fear that shaped Jersey's relationship with France. As a front-line defence for Britain in any conflict with France, the island had to be appropriately protected and during the eighteenth and nineteenth centuries, defensive towers were erected around Jersey's coast. Three of these were constructed during the 1830s in St Ouen's Bay on Jersey's west coast, with Kempt Tower named after Sir James Kempt, the master general of the Board of Ordnance at this time.

The long arc of St Ouen's Bay was considered susceptible to attack, particularly as it lacks the natural defences provided by the north coast's towering cliffs. The nineteenth-century towers Rocco, Lewis and Kempt therefore stand guard over the bay. While Rocco's design is that of a Jersey round tower, Kempt and its near neighbour Lewis are Martello towers and similar to others built on England's south and south-east coast for the same purpose.

Kempt Tower is approximately 11 metres tall and 8 metres in diameter, and this circular granite fortification accommodated around ten soldiers. On the tower's

roof, a cannon on a rotating platform enabled those operating the gun to sweep it back and forth to defend more of the bay.

Like other existing military towers, Kempt Tower was utilised by the Germans during their occupation. They built several bunkers around the tower to defend St Ouen's Bay, and this assortment of new and old defences were collectively called Resistance Nest Kempt Tower.

Ironically, while the tower was originally intended to aggressively defend against enemy attack, as a Jersey Heritage holiday let for both visitors and locals, its purpose now is definitely peaceful. Located within the island's beautiful National Park, which 'aims to protect, conserve and enhance [Jersey's] natural beauty, wildlife and cultural heritage', the tower affords wonderful views of the bay, extensive sand dunes, and of stunning sunsets when facing west overlooking the waves of the Atlantic Ocean.

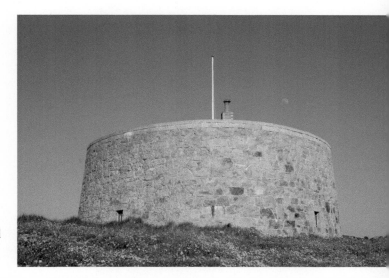

Right: Kempt Tower from the beach. (© Barney De La Cloche)

Below: Kempt Tower, located in Jersey's National Park. (© Barney De La Cloche)

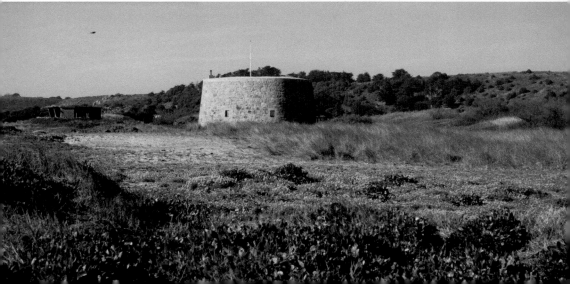

19. Fishermen's Cottages

Oysters and Shipbuilding

Jersey has many remarkable houses, and it's possible to see historic manors, Victorian villas, Georgian mansions and art deco homes when exploring the island. But not all of Jersey's memorable houses are grand, and some of the most charming dwellings can be found down a quiet lane in Gorey Village.

The terraced cottages along Old Road are attractive, some painted in pastel shades with pots of flowers adding to the picturesque scene. Now desirable homes for twenty-first-century families, these houses were built in the early nineteenth century and evidence the commercial enterprises that irrevocably shaped Gorey Village.

Jersey's big tides and clean waters provide the perfect environment for oysters and fish, and the fishing industry flourished here through much of the nineteenth century. Attracted by potential profits, English and local fishing companies were involved and the several thousand strong workforce required to sustain the trade, as well as those employed in Gorey's shipbuilding industry, needed accommodation and essential facilities. So, the cottages in Old Road were built, together with schools and churches like nearby Gouray Church, constructed in 1833.

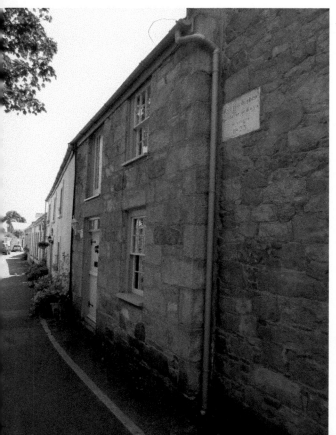

Gorey fishermen's cottages with a plaque noting 'there is more pleasure in forgiving than [...] in revenge'. (© Simon Radford)

Some estimates state that at the oyster industry's peak, a boat's average daily catch was around 12,000 oysters, a vast number but ultimately impossible to sustain as aggressive over-fishing impacted the oyster beds. The island's authorities attempted to protect the industry in the late 1830s by laying down new oyster beds in Grouville Bay and banning fishermen from the area until the oysters matured. However, the temptation proved too much and in 1838 over 100 fishing boats ransacked the beds. Despite local militia intervention, the fishermen were undeterred and this episode in Jersey's history has been dubbed the Oyster Riots, or Battle of the Oyster Shells.

By the late nineteenth century as oyster numbers declined, oyster fishing became virtually non-existent. However, the cottages continued to provide homes and Gorey Village thrived, as its shops and hotels were boosted by the arrival of the railway carrying tourists and day trippers.

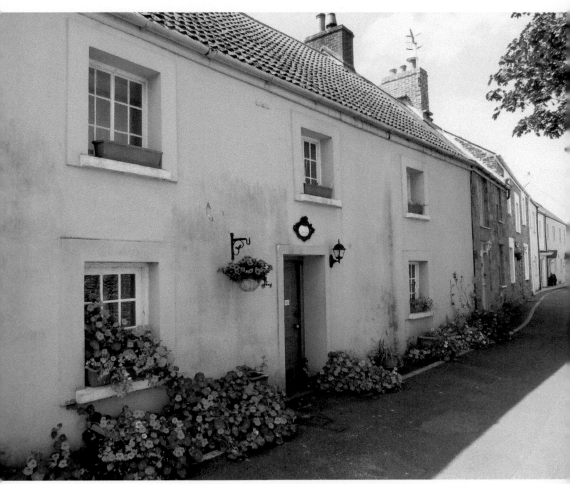

Gorey Village fishermen's cottages. (© Simon Radford)

A last word on oyster fishing though because Gorey's oyster tale isn't quite over. Happily, with the reinstatement of oyster production in the Royal Bay of Grouville, this historic industry is flourishing once more, and Jersey oysters are back on the menu.

20. Voisins Department Store

The British Isles' Oldest Family-owned and -run Department Store

Two department stores founded in the early nineteenth century are located on King Street, part of St Helier's main shopping area. While De Gruchy's and Voisin's continue to provide all manner of goods and services in the twenty-first century, one of them can claim to be the oldest family owned and run department store in the British Isles.

Voisins Department Store has been operated by successive members of the same family for almost 200 years and is housed in a building that has evolved and been shaped by each generation. The store, founded in 1837 by Francis Voisin, began selling haberdashery and items such as gloves and hosiery in a shop situated in No. 26 King Street. Over the years as the business prospered, Francis and his descendants expanded the store by buying adjacent properties in King Street and New Street. These newly acquired buildings didn't just make space for the firm's

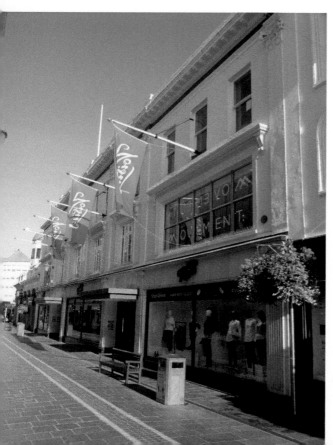

Voisins Department Store today.
(© Simon Radford)

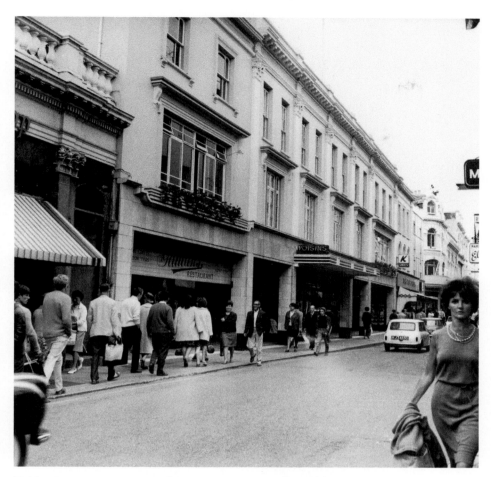

Voisins Department Store in the 1960s. (Courtesy of Gerald Voisin)

wares, customers and two-legged employees though; once upon a time they also provided stabling for the horses that pulled the store's delivery carts.

The store's frontage on King Street has always featured large windows in which to display goods, although these have been remodelled several times over the years. However, photographic images from various years reveal that some details have been retained including canopies over the first-floor windows, pilasters and decorative mouldings.

The store's current owner and operator is Gerald Voisin, and his vision has driven a transformation of this Jersey institution's interior space, which now features two storeys of bright and contemporary shop floor. Like his entrepreneurial ancestors, Gerald has diversified and broadened the variety of goods in the store since he took control in 1992. High-street brands are sold alongside designer items and customers can purchase all manner of items ranging from a lipstick or suitcase, and top-end fashion to a pair of socks.

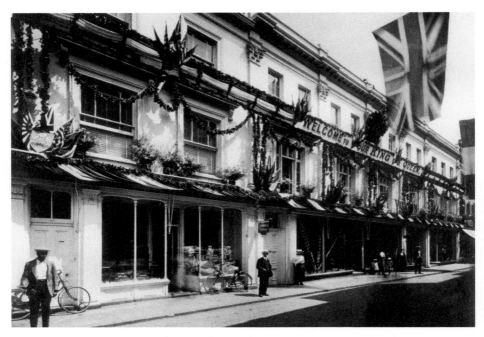

Voisins Department Store, decorated to welcome King George V and Queen Mary. (Courtesy of Gerald Voisin)

21. Victoria and Albert Quays

War, Trade and Tourism

Queen Victoria and Prince Albert visited Jersey in 1846 and 1859, and to mark these occasions, two new St Helier Harbour piers were christened the Victoria and Albert Quays. Now as back then, the facilities they provide help maintain Jersey's economy, its tourism industry and its supply chain, and the quays are also noted for the part they played in the island's occupation tale.

During the Second World War, the quays were the focus of several events. The Royal Militia of the Island of Jersey left to join British forces from the Albert Quay on 20 June 1940. Eight days later prior to invading, the Germans bombed the harbours and other parts of the island, killing nine islanders in the process. In September 1942, over 1,000 British men and their families were deported to internment camps in Germany from Albert Quay, and the Red Cross ship SS *Vega* carrying desperately needed humanitarian relief for islanders docked here in December 1944. Several plaques along the quays mark these episodes.

A walk along the quays now reveals that they are still busy places. Boats arrive and depart from here; dockworkers go about their business on the quaysides and sailors, as well as landlubbers, can often be found putting the world to rights at the harbour's cafés.

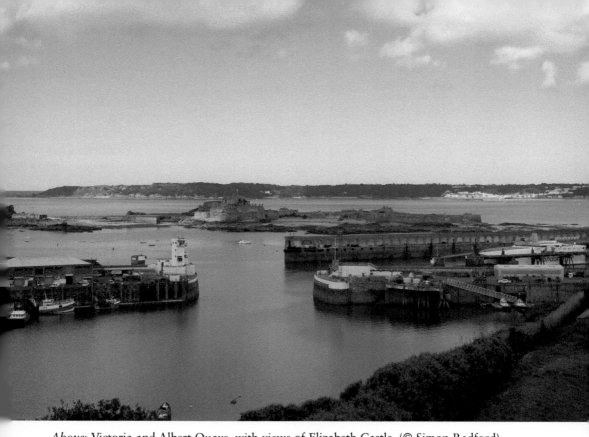

Above: Victoria and Albert Quays, with views of Elizabeth Castle. (© Simon Radford)

Below: Victoria and Albert Quays and St Helier's harbour. (© Simon Radford)

22. Almorah Crescent

New Homes for New Arrivals

In June 1815, Napoleon's subjugation of Europe ended with his army's defeat at the Battle of Waterloo. In the ensuing peace, Jersey's population began to swell with demobilised British military personnel who, with their families, were drawn to the island for reasons such as its quality of life and low taxes. Demand for homes suitable for these 'genteel' folk led to the construction of smart crescents and terraces in St Helier, like Windsor Crescent and Gloster Terrace, with Almorah Crescent's ten houses enjoying views of St Helier below.

Although built in the early years of Queen Victoria's reign, Almorah Crescent's style is considered Regency because it has design details of that period. The exterior is stucco fashioned to resemble large blocks, and an elaborate first-floor ironwork balcony runs the length of the crescent. The second-floor windows are enhanced by decorative hoods, and smaller sash window on the top floor complete the picture.

The gentle sweep of Almorah Crescent. (© Simon Radford)

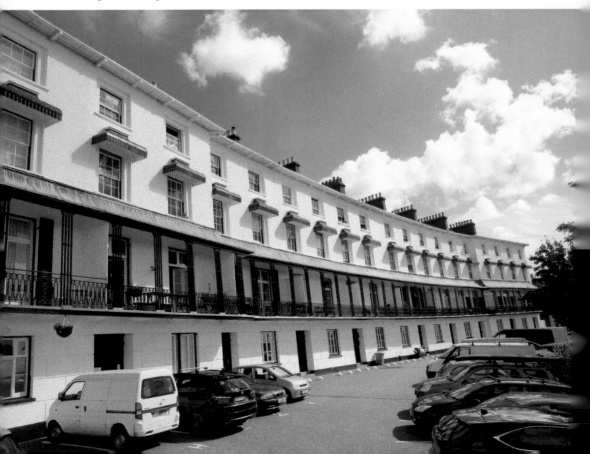

These elegant four-storey properties reflect major economic and social developments taking place in Jersey during the 1800s, themes which feature throughout this book. Almorah Crescent would have been a desirable place to live, particularly as its residents may have equated their place in society with the crescent's elevated location above St Helier.

23. St Catherine's Breakwater

A Harbour ... That Never Was

Suspecting a resumption of French hostilities in the mid-1840s, Britain initiated a plan to build a harbour of refuge for Royal Navy warships as close to France as possible. The chosen location was Jersey's St Catherine's Bay, just 14 or so miles from the French coast, and the plan was to construct two arms stretching out to sea, one from St Catherine's itself and the other from Archirondel. This would create a large, protective anchorage for the naval vessels. However, some people like hydrographer Admiral White believed this site to be inherently flawed due to the bay's propensity to silt up, and that it was therefore just not deep enough to accommodate ships safely. Nevertheless, these concerns were ignored, and construction began.

Eight years on, things were not going well. Concerns about the insufficient depth of the proposed harbour proved correct; the project was massively over budget;

St Catherine's Breakwater. (Courtesy of Visit Jersey)

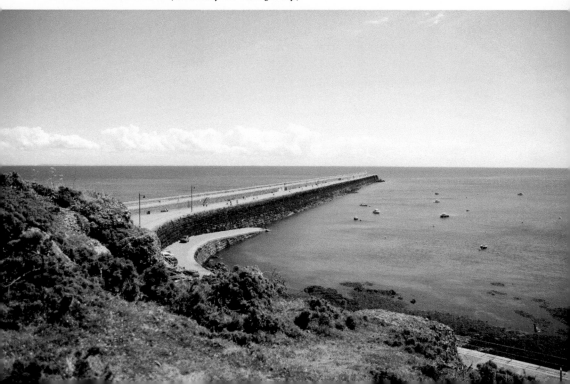

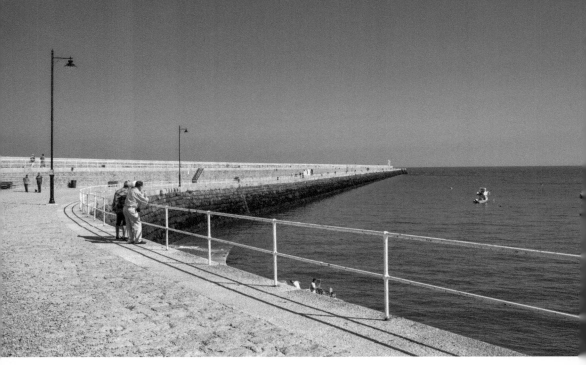

Strolling along St Catherine's Breakwater. (Courtesy of Visit Jersey)

and predictions of a renewed French offensive against Britain proved incorrect. So, the decision was made to abandon the plan for the Archirondel arm of the harbour and just complete St Catherine's. This was built from locally quarried stone and is approximately 700 metres long, with two levels along its length and a slipway that gives direct access to the sea below.

Although failing as a harbour, the breakwater has been put to good use over the years. It was from St Catherine's that Queen Victoria rejoined the royal yacht following her 1859 visit to Jersey; kayakers and scuba divers use the breakwater as the starting point of their maritime adventures and St Catherine's Sailing Club is based here. If you fancy doing something a little different, take a look at the Turbot Farm, situated in a Second Word War German bunker nearby. This is a great spot for fishing and a popular place to stroll and admire views of the French coast and Ecrehous, a protected reef of rocks between Jersey and France

24. The Central and Fish Markets

Local Produce in Historic Surroundings

While Jersey is serviced by several well-known supermarkets, islanders have other shopping choices available, especially when it comes to local produce. One way to buy your Jersey Royals, cauliflowers or onions is to visit a roadside 'hedge-veg' stall where payment is placed in an 'honesty box'. A tip is to have the correct money with you, although some boxes do now accept payment by card. However,

if you wish to fully appreciate the abundance and variety of local produce, then look no further than St Helier's Central Market and Fish Market.

The Central Market is one of St Helier's most notable landmarks. Built in the 1880s to commemorate the centenary of the 1781 Battle of Jersey, the building is filled with Victorian architectural detail. Its granite exterior is punctuated by several elaborate iron gates and the interior is light and airy with thirty-seven cast-iron columns supporting the metal roof structure. Originally glazed with glass weighing around 80 tons, the roof now comprises a lighter-weight material. At the heart of the market is a fountain, an extravagant display of nineteenth-century ornamentation with its three tiers, plump cherubs and bold colours. The market accommodates many stalls that sell a diverse range of goods from fruit and vegetables to meat and local crafts, all of which add vibrant colour to this Victorian market hall.

A stone's throw away is the Beresford Street Market or, as locals call it, the Fish Market – because that's what it sells! Although the original market was built in the 1840s, it has undergone several refurbishments since. Nevertheless, it has retained its authenticity and reflects its neighbour's granite exterior and iron gates. Inside there are numerous Jersey fishy temptations on display at the fishmonger's stalls, which, according to season, include lobster, crab and prawns, oysters, mussels and fresh mackerel.

Finally, when your bags are full of tasty local treats, spend a few minutes taking in these architecturally interesting and historic surroundings, which are accessible from Monday to Saturday, 7.30 a.m. until 5.30 p.m., apart from Thursday when the market closes at 2.30 p.m.

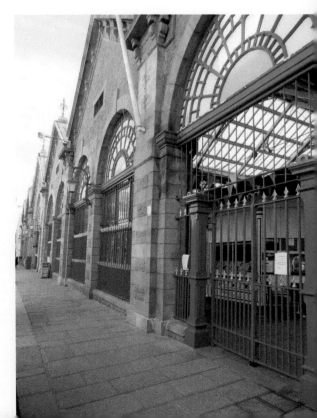

The Central Market, Halkett Place entrances. (© Simon Radford)

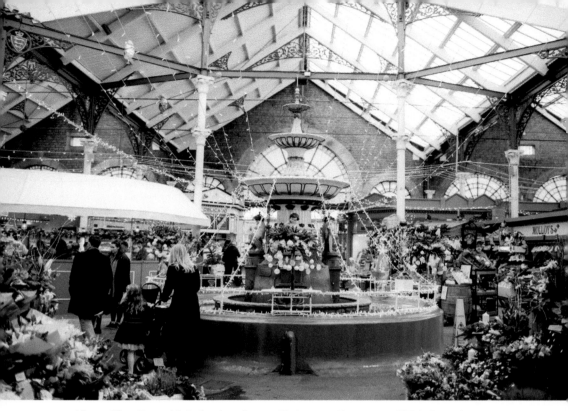

Above: The Central Market interior at Christmas. (Courtesy of Visit Jersey)

Below: An array of seafood at the Fish Market. (Courtesy of Visit Jersey)

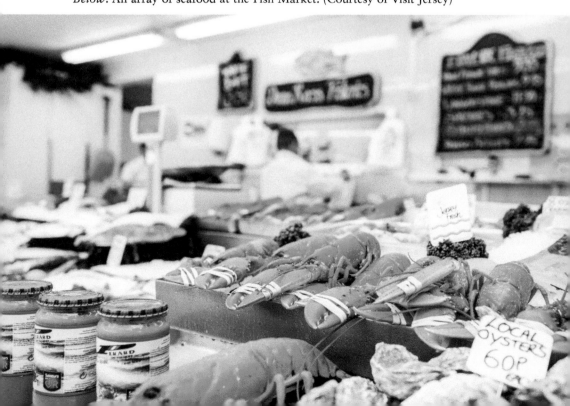

25. Victoria College

Tradition and Teaching

From the mid-1800s the sight of what seemed to be three impressive fortifications protecting the town and harbour of St Helier may have caused would-be invaders to rethink an attack on Jersey. This scene was, however, misleading, as only two of the structures, Elizabeth Castle and Fort Regent, were defences. The third, despite its imposing appearance, was a boys' school named after Queen Victoria, who visited it in 1859.

Victoria College opened in 1852 and the architecture of its original buildings is consistent with the Gothic revival trends of that time. The principal grey granite building with its crenelations, towers and church-style windows resembles a castle. Inside, its Great Hall has a hammerbeam ceiling and within the windows the crests of Jersey's twelve parishes, the monarch and States of Jersey are displayed in stained glass. If asked to describe this part of Victoria College, a comparison with Harry Potter's alma mater Hogwarts School would not be unreasonable! Other buildings including science blocks and a theatre have been added over the years, some designed in the Gothic style and others being more of their own time. Together they now accommodate around 700 students.

The education received here in the nineteenth century was based on the English public-school model. This reflected an emerging Anglicisation of many aspects of Jersey's culture, which was driven by increasing numbers of British nationals relocating to Jersey.

The learning experience of students now is definitely contemporary though, and the boys have access to excellent modern resources. Nevertheless, the school

Victoria College's Great Hall. (© Simon Radford)

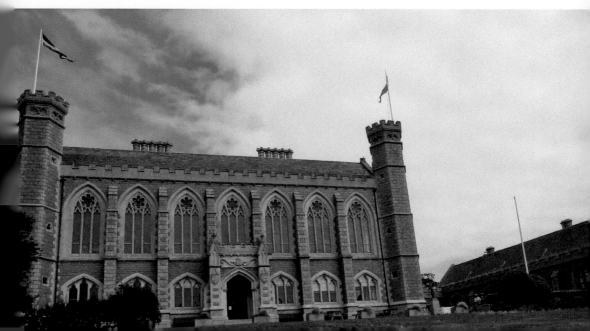

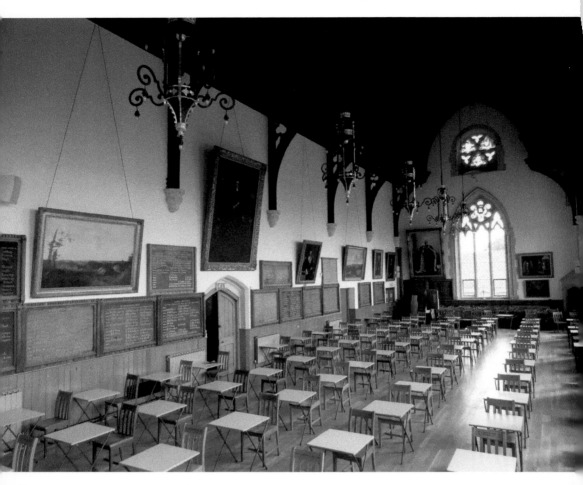

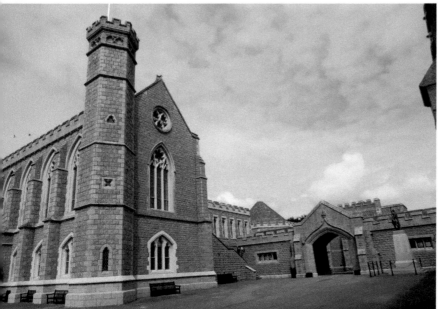

Above: Inside Victoria College's Great Hall. (© Simon Radford)

Left: Great Hall, Quadrangle and Sir Galahad statue, Victoria College. (© Simon Radford)

is mindful of traditions like its long-term links with Britain's armed forces. The names of old boys who have joined the military are displayed in school, with several Old Victorians having received the Victoria Cross.

Victoria College's buildings, traditions and student experiences help us to understand Jersey's unique past and present. The varied lives of many Old Victorians demonstrate that islanders, undaunted by the diminutive size of their home, often 'dream big', with Victoria College alumni including politicians, explorers and Hollywood actors.

26. The States Chamber and Royal Court

Legislature and Judiciary

A possession of the British Crown but not part of the United Kingdom, Jersey is autonomous with a government that is not controlled by Britain. However, the laws Jersey's government makes must be approved by the British monarch's Privy Council.

This independent administration, historically known as the States of Jersey, is accommodated in a building in St Helier's Royal Square and while not uniform in appearance, the edifice nevertheless looks suitably eye-catching. As well as being the island's legislative heart, the building also houses the Royal Court, Jersey's highest court of law, and provides space for administration and offices for the Bailiff, the island's chief judge and speaker of the States.

The States Chamber and Royal Court. (© Simon Radford)

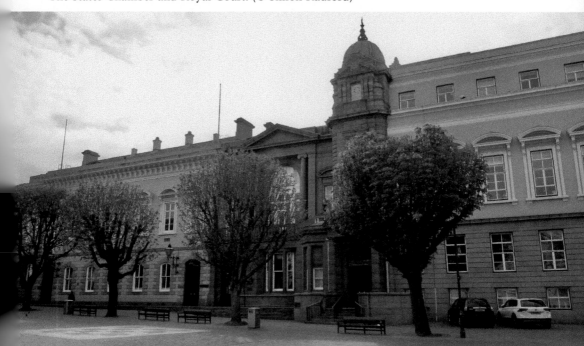

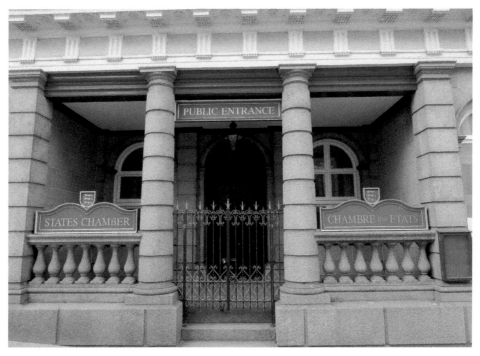

Public entrance to the States Chamber. (© Simon Radford)

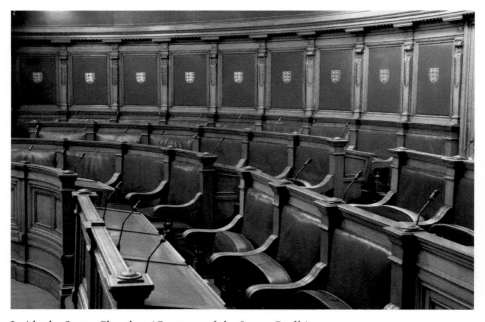

Inside the States Chamber. (Courtesy of the States Greffe)

Above the public entrance to the Chambre des Etats, or States Chamber, is a striking lilac-coloured façade comprising arched windows, pilasters, decorative mouldings and a pediment with ornamental motifs. In contrast, access for State's members is through a modest wooden door on the building's Royal Square side.

Inside, elected State's members; thirty-seven deputies and twelve parish connétables, convene in the oak-panelled chamber, which was opened in 1887. Members' red leather seating is arranged in a horseshoe around the Bailiff's desk and Jersey's Royal Mace rests in front of this. Charles II gifted this staff of office to the people of Jersey in 1663, and it signified his appreciation of their loyalty and the sanctuary they gave to him and his brother (later James II) during the English Civil War.

The building's central Royal Court section was built in 1866 and upgraded in 1877. Presiding over the court are the Bailiff and Jurats (elected judges), who are seated on a raised wooden platform facing the accused. Those attending the trial sit on pew-like benches within the court.

It is possible to see the State's Chamber for yourself during public viewing of proceedings on Tuesdays. However, the Royal Court is a different matter and doing anything that might bring you here is probably best avoided.

27. St Brelade's Bay Hotel

A Hotel with History

The glorious bay of St Brelade is a favourite of locals, and many visitors stay here during their Jersey holiday. At the westerly side of the bay is an hotel that has accommodated visitors since the early years of Jersey tourism, and which continues to do so today.

St Brelade's Bay Hotel began welcoming guests in the latter half of the nineteenth century and parts of its current façade would probably seem familiar to those initial visitors. This was a time when a number of factors together drove tourism forward to make Jersey a feasible and desirable holiday destination. Expanding British and European railway networks and regular ferry services to Jersey enabled Victorian visitors to escape the smog and grime of industrialising cities and to make the most of the island's clean air and sea-bathing opportunities, a trend set by Queen Victoria and Prince Albert. Victorian's also started to see travel as more than just a way to get from A to B, and they began to enjoy exploring new places.

During the 1920s and 1930s, Helen Colley took charge of the hotel and embarked on a programme of development that saw the hotel grow and its gardens flourish. However, this was interrupted when the hotel was requisitioned by the German army during their occupation of Jersey from 1940 to 1945. They used the hotel as a billet for the Luftwaffe Long-Range Reconnaissance group F.123, then as a *Soldatenheim*, a place in which German soldiers could

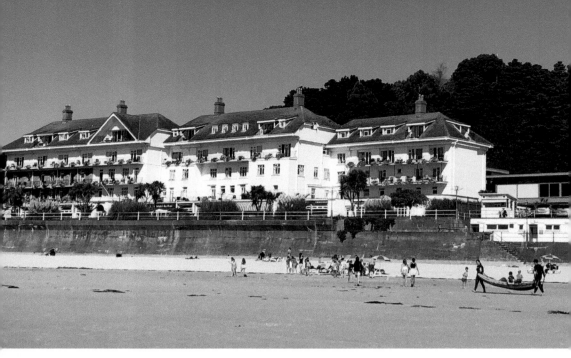

Above: St Brelade's Bay Hotel. (© Simon Radford)

Below: St Brelade's Bay Hotel and its seaside garden. (© Simon Radford)

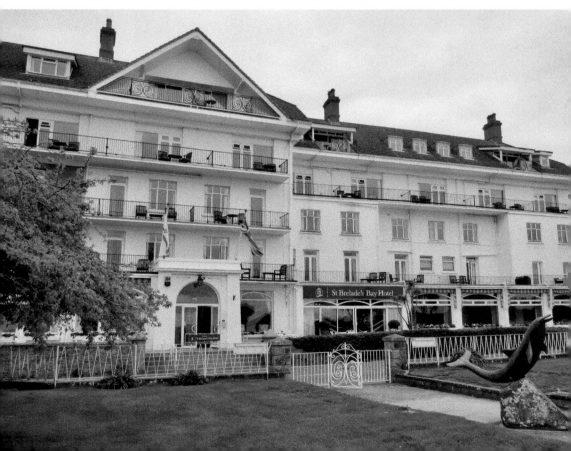

relax and rest. Occupation expert Colin Isherwood notes that due to its beach-front location, this *Soldatenheim* was the most popular in the island and that reminders of this time still exist, one being an air-raid shelter under the lawn in front of the hotel.

Following liberation, the disorder left by the Germans was transformed by Helen's son Bob, and regular refurbishment by subsequent owners has been ongoing ever since. The hotel is charming and its location by St Brelade's golden, sandy beach ensures that guests enjoy one of the island's most stunning views.

28. Corbière Lighthouse

Jersey's Iconic Maritime Beacon

Jersey's south-west tip is a beautiful and dramatic section of coastline and provides the perfect location from which to enjoy magnificent views of St Ouen's Bay and the islands of Guernsey, Sark and Herm. However, the prevailing winds, jagged granite rocks and the powerful tides surging between them make this a potentially hazardous location for shipping. It is said that Jersey fishermen believed this to be the most treacherous part of their voyage to and from the fishing grounds of Newfoundland.

Corbière Lighthouse. (© Barney De La Cloche)

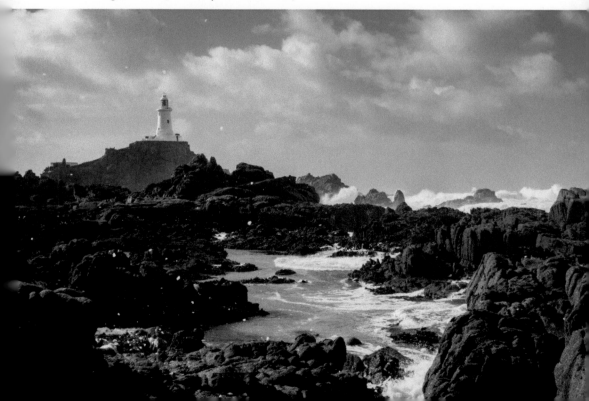

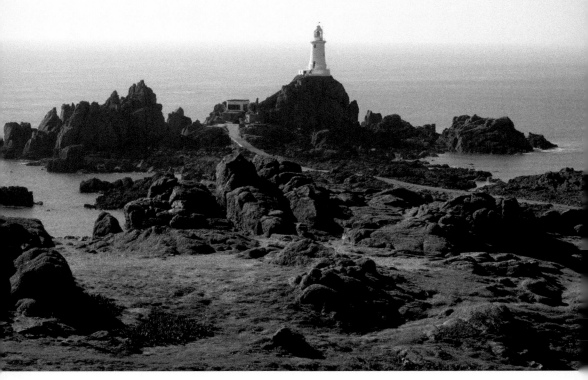

Corbière Lighthouse at low tide. (Courtesy of Visit Jersey)

Despite mariners' repeated requests to the authorities asking that a lighthouse be built at Corbière, it wasn't until the 1870s that one was constructed, with Sir John Coode the architect and Imrie Bell the engineer. The lighthouse was the first made of concrete in the British Isles and building materials for it were hoisted into position from tugs that brought them from the shore. The workforce lived in huts on site for the duration of the lighthouse's construction.

Perched on top of the jagged rocks, the lighthouse's all-important lamp was originally fuelled by paraffin which required a team of men working in shifts around the clock to ensure it was always lit. Today the lamp is electric and automated, with a range of 18 nautical miles, and the lighthouse has a radio beacon to enhance its effectiveness.

While now operating with twenty-first-century efficiency, the lighthouse interior retains many original brass and wood fittings. These help give a sense of the lighthouse life experienced by the four keepers who once watched over it and who, when not working, lived in cottages nearby.

Corbière Lighthouse is one of the island's most well-known structures. It appears in many holiday snaps and is often the first landmark spotted by eagle-eyed visitors when they arrive by air. While there are no regular tours of the lighthouse, they do happen occasionally and are highly recommended.

29. The Town Hall

Salle Paroissiale de St Helier

Jersey is divided into twelve parishes, with each having a parish hall except St Martin, which has a public hall. They are the administrative centre of the parish and home to its Assembly, which manages such matters as road maintenance, rates and issuing driving licences to parishioners. The parish or public halls hold community events and form the hub of the parish along with a primary school, church and generally a pub or two.

Known locally as the Town Hall, St Helier's parish hall dates from 1872 and its embellished exterior provides design enthusiasts with an interesting contrast

St Helier Town Hall flying the Union, Jersey and St Helier parish flags. (© Simon Radford)

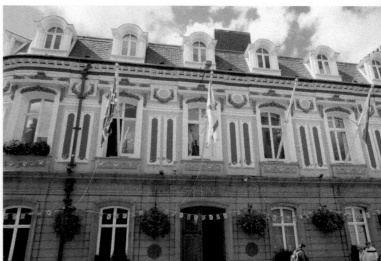

St Helier Town Hall entrance. (© Simon Radford)

to the less complicated lines of the town's eighteenth-century architecture. The dressed granite exterior of the ground floor conveys strength and dependability, with tall windows and decorative features perhaps intending to communicate the importance of the municipal matters going on in the lofty assembly hall and meeting rooms within.

First used as a base for the police and fire brigade, the Town Hall played a central role in the evacuation of locals to England following the demilitarisation of Jersey in June 1940. Anticipating occupation by the enemy, it was decided to evacuate those who wished to leave before this happened. To facilitate this, islanders had to register at the Town Hall and occupation hero, the late Bob Le Sueur, remembered the packed queues of people desperate to apply, which stretched from the Town Hall to at least as far as the Opera House in Gloucester Street. These people, with only the luggage they could carry, were then transported to the mainland on every available vessel before the enemy arrived.

As well as providing a space for serious parish business, the Town Hall also hosts less weighty occasions. These include St Helier's annual Liberation Day commemorations on 9 May and Vin D'Honneurs, events that celebrate individuals or groups such as visiting dignitaries or sportsmen and women. The Town Hall with its striking exterior and interior is an ideal location to hold such memorable events.

30. Georgetown Methodist Church

An Island with a Nonconformist Tradition

Jersey's spiritual community encompasses faiths such as Anglicanism, Roman Catholicism and Judaism, as well as Methodism, which became particularly popular through the nineteenth century. Numerous chapels were built to accommodate

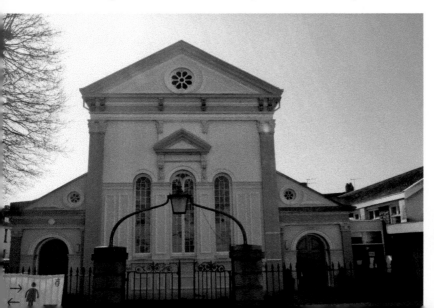

Georgetown Methodist Church. (© Simon Radford)

growing congregations of Methodist worshipers in the island and eight of these remain active, with Methodism still an active constituent of Jersey's religious character.

The thirty-seventh chapel, built in 1873, was Georgetown Methodist Church, a striking edifice constructed in the classical manner. Its exterior is embellished with features common to such architecture, including pediments and pilasters, and the interior space has pictorial glass windows and arched doorways.

The construction of so many Methodist chapels in just one century may prompt readers to ask why this Nonconformist religion gained such traction during the 1800s, particularly in an island with an established Anglican and Catholic tradition. The answer is attributable to several seemingly unconnected factors including fishing, the military and immigration.

Methodism arrived in Jersey in the 1770s via two fishermen, Jean Tentin and Pierre Le Seuer, who had been introduced to it in Newfoundland. They preached this new religion in Jersey around the same time that an English army regiment was posted to the island. Methodists in these ranks were accompanied by a preacher who was able to accommodate their spiritual needs, and who of course spoke their mother tongue. However, John Wesley, brother of Methodism's founder Charles Wesley, required a translator to deliver his sermons to the island's French speakers during his visit to Jersey in 1787. Many of these people were descendants of French Calvinist immigrants who had sought refuge from Catholic persecution in Jersey during the seventeenth century, and who were attracted to Methodism because it resonated with their religious heritage.

While the factors above helped facilitate the growth of Methodism in Jersey, another one should also be mentioned. Jersey men and women have always had a strong sense of self and an independent spirit, so perhaps it's not surprising that many were drawn to a faith system based on having a more personal and autonomous relationship with God.

31. St Helier Yacht Club

Races, Regattas and Rescues

Getting on the water is popular in Jersey with sailing unsurprisingly a well-loved pursuit. Several clubs cater specifically for local mariners, with one, according to its manager, having the largest membership of any club in Jersey.

Formed in 1903, St Helier Yacht Club moved to its current premises in 1950. The building was once a coal store for steamers running between Jersey and France, and its harbourside location offers views of St Helier's busy harbours. The club's chart room has floor-to-ceiling windows and its unique appearance resembles the bridge of a ship. Inside, the space is welcoming and appropriately decorated with various maritime motifs like pennants and model ships.

One of the club's most well-known members was sailor and philanthropist T. B. Davis, and memorabilia from his schooner *Westward* is exhibited here. It is

Above: St Helier Yacht Club and harbour. (© Simon Radford)

Left: St Helier Yacht Club and Westward's mast flying the defaced red ensign. (© Barney De La Cloche)

from what was *Westward*'s mast that the club's noteworthy flag flies outside. But why is this flag so special? Well, to answer this question we must focus on a heroic rescue that occurred in 1940, just after a fleet of 'little ships' from Britain helped evacuate approximately 300,000 Allied troops from the beaches of Dunkirk and away from advancing German forces.

Allied troops were also retreating to Brittany's port of St Malo at that time and Britain's Admiralty called upon Jersey to help evacuate them immediately. Local seafaring volunteers, including crews from St Helier Yacht Club, bravely answered this

appeal. They sailed to St Malo and helped rescue around 28,000 military and civilian personnel. All boats returned safely, and the Admiralty sent a telegrammed message of thanks, a document that is proudly displayed in the clubhouse for all to see. For its members' participation in the evacuation, the club received the honour of 'wearing' a Red Ensign defaced with an anchor and crossed axes, the parish of St Helier's emblem. This flag today flies from members' boats as they participate in races and regattas and is a constant reminder of St Helier Yacht Club's extraordinary wartime tale.

32. St Mary's Primary School

Education, Then and Now

While children in Jersey can attend non-fee-paying state schools, this has not always been the case. Certainly, from the fifteenth century until the late 1800s, education was usually limited to wealthy boys who attended schools run by the Church.

This situation began to change when in 1787 an increasing appetite to educate more of the island's children ended the Church's exclusive governance of schools.

St Mary's Primary School. (© Simon Radford)

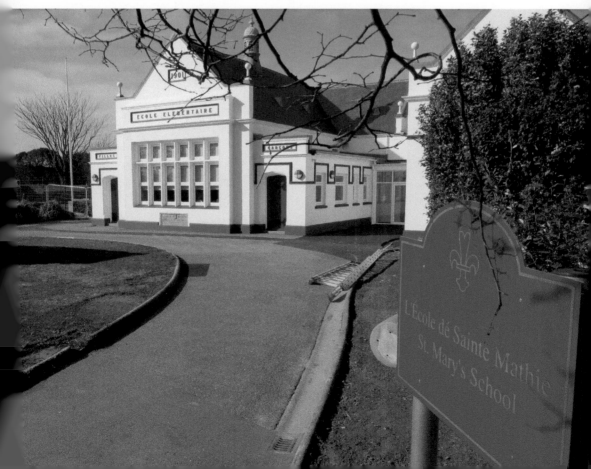

This quest to make learning more accessible continued over the years, with education being made compulsory for children aged five to twelve in the 1890s and the establishment of a government-managed school in each parish by 1913.

One such parish school, St Mary's Primary School, opened its doors in 1901, a date displayed on the building's original frontage along with '*ECOLE ELEMENTAIRE*', '*FILLES*' and '*GARÇONS*'. These words are evidence that this was a primary school for boys and girls, and that in 1901 French or its local equivalent Jèrriais, were the predominant languages spoken here.

The school has been developed over time, but its original building remains at the heart of student life. Like other parish schools, St Mary's is an essential part of the local community, and it highlights the educational experiences of Jersey's children, past and present.

33. Broad Street Post Office

Communication, Connectivity and Community Services

Islanders posting letters or visitors sending postcards may well do so from St Helier's Broad Street post office, with other services here including a foreign currency exchange, utility bill payment and lottery ticket sales. These amenities are accommodated within an Edwardian building that opened as Jersey's main post office in 1909.

Above the entrance, columns and arches adorn the façade. There are three carved wreaths, with the central one bearing a crown and initials 'ER VII', referencing Edward VII, Britain's king when the post office opened.

The early nineteenth-century post office with its twenty-first-century facilities, represents key developments in Jersey's postal service which today help facilitate

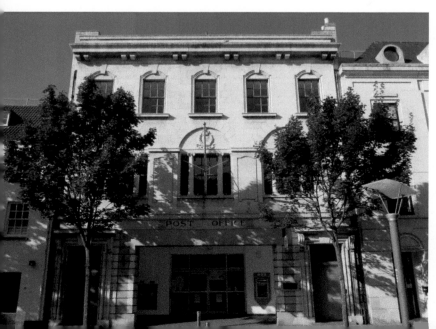

Broad Street post office. (© Simon Radford)

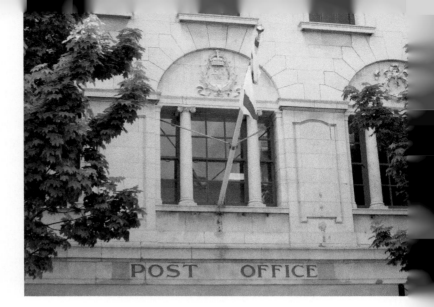

King Edward VII's crest,
Broad Street post office.
(© Simon Radford)

communication and connectivity locally and further afield. This is vital for the island's community and businesses, although the need to communicate beyond the island is not a new occurrence.

Before 1794, some ships' captains, for a fee, carried mail and then on arrival in England passed it onto a postmaster for delivery. A more organised system began from 1794 when Jersey's first post office in Hue Street opened and official post office vessels started to carry the mail.

By the mid-1800s demand for a more efficient service led to English post office surveyors coming to the island to investigate how best to overhaul the system. Among their number was Anthony Trollope, who is probably better known as an author. This scrutiny resulted in the installation of postboxes throughout the island, establishment of routes for collection and delivery by authorised postmen, and creation of a centralised sorting depot. Postboxes were a new innovation, tested in the Channel Islands by Trollope and his colleagues before the concept was rolled out in England, and several early boxes can still be seen in Jersey, including a rare 1860s Penfold Pillar Box located in the Central Market.

Having separated from the United Kingdom government in 1969, the island's postal service is now an independent organisation known as Jersey Post, whose state-of-the-art resources ensure that the safe delivery of letters, parcels and postcards is no longer reliant on unpredictable ships' captains.

34. Old Station Café

A Reminder of Jersey's Railway Heritage

Railways once played their part in transporting locals, visitors and industry around Jersey. Opening in 1870, the Jersey Western Railway ran from St Helier to St Aubin, with extensions to La Moye and Corbière added later. Another line from St Helier to Gorey, which was operated by the Jersey Eastern Railway, opened

for business in 1873. While they no longer run, reminders of Jersey's railway era remain, including a building that overlooks St Aubin's Bay.

Old Station Café is located on what was the Jersey Western Railway line and it was known as Millbrook station. Opening in 1912, it replaced the area's first station and still has features from that time. The raised area outside the café was the platform, and the canopy over the main door has retained its scalloped edge, a theme that ran throughout the station. The café's main interior space with its Edwardian wooden ceiling was the waiting room and the ticket office was located in what is now the kitchen.

This popular café's owner, Gerry Flynn, is so committed to ensuring that its place in Jersey's transport story is not forgotten, that he commissioned local artist Kevin Pallot to create a mural of the *Corbière,* one of the engines that once stopped at the station. This is displayed on the café's exterior in the place where the railway line ran.

The demise of both railways by 1936 was engendered by the arrival of motorised buses, private motor cars and the loss of most of the Western Railway's stock in a fire at St Aubin's station. The Germans reinstated a railway line during the Occupation to transport materials used in the construction of their defences, but this was decommissioned following liberation.

These days of steam have left an enduring legacy for Jersey's community. Some stations are now homes, others like the Old Station Café provide a place to dine and socialise, and the Western Railway's route from St Aubin to Corbière has been transformed into the Railway Walk, a scenic path for cyclists and pedestrians to enjoy.

Old Station Café and Corbière steam engine mural. (© Simon Radford)

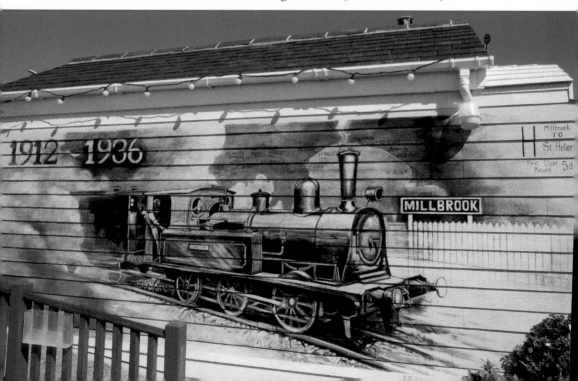

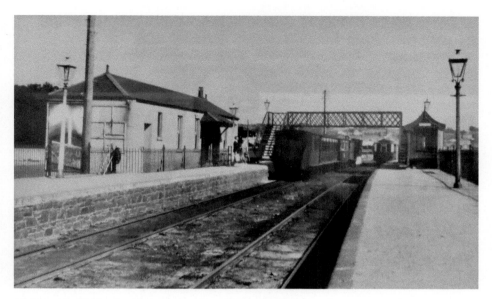

Old Station Café when it was a station. (© Gerry Flynn)

35. Jersey Fire and Rescue Headquarters

An Emergency Services Base with a Military Past

The name of the States of Jersey's Fire and Rescue Service reveals that island firefighters don't just deal with fires. They also attend incidents like cliff and sea rescues and road traffic accidents. The service is based on Rouge Bouillon in St Helier, in a granite building that has been the service's headquarters since the 1950s. The building was constructed in the early twentieth century and was originally intended to fulfil a function considered necessary by the States of Jersey, although contentious by others, but more of that later. Let's first hear about another aspect of the building's story.

No official fire service operated on the island before 1902, but in that year the St Helier Fire Brigade was established and based in the Town Hall. Clad in dashing uniforms and brass helmets, these first firemen attended blazes in horse-drawn, steam-powered fire engines until motorised engines were acquired.

Operating throughout the Occupation, the brigade moved to its current site on Rouge Bouillon in the 1950s. The town location of the Fire and Rescue Services' HQ means that today passers-by can observe firefighters undertaking live fire drills in a special structure on site or speeding off to an emergency in impressive red fire engines from the building's ground floor depot.

The building was originally constructed as an arsenal, although this decision was not well received by all members of the town's population. The States of

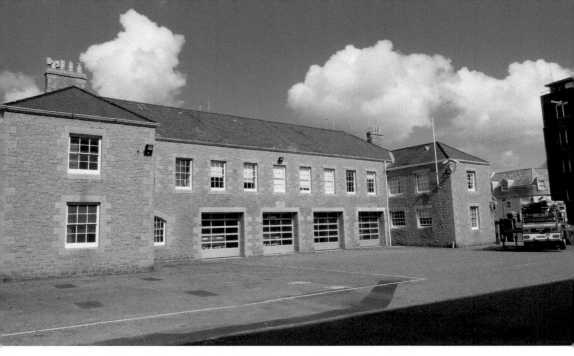

Jersey Fire and Rescue Service Headquarters. (© Simon Radford)

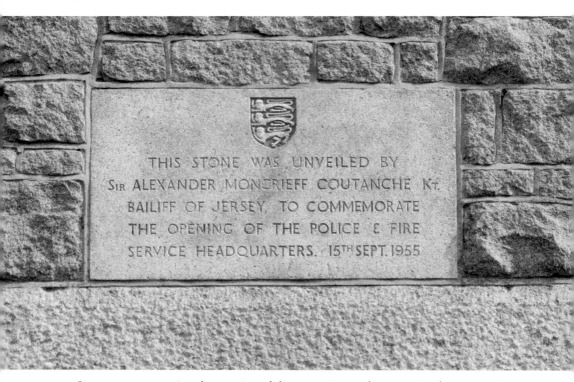

THIS STONE WAS UNVEILED BY
Sir ALEXANDER MONCRIEFF COUTANCHE Kt.
BAILIFF OF JERSEY, TO COMMEMORATE
THE OPENING OF THE POLICE & FIRE
SERVICE HEADQUARTERS. 15TH SEPT. 1955

Stone commemorating the opening of the Jersey Fire and Rescue Headquarters. (© Simon Radford)

Jersey had indicated its intent to build such a weaponry on Rouge Bouillon in the early 1900s and this elicited strong protests by many locals. Rouge Bouillon was considered a well-to-do residential area and homeowners were concerned that the presence of such a military facility would drive house prices down, undermine the respectable character of the locale, as well as pose a significant safety threat. However, despite these objections and anxieties, construction went ahead in 1917. The building continued to operate in a military capacity until after the Occupation, with the Fire Service taking it over in 1955.

36. The Cenotaph

Remembering Islanders Who Gave Their Lives in War

Every year at 11 o'clock, on the nearest Sunday to the 11 November, eleven sombre chimes ring out over London from Big Ben. This sound calls those who hear it to observe two minutes of silence and to remember the millions who have died in war. The focus of national remembrance is on the Cenotaph in Whitehall but acts of commemoration also occur at war memorials and cenotaphs elsewhere in the British Isles, including Jersey.

Cenotaph means 'empty tomb', and this is key to understanding the significance of these memorials, which began to appear after the First World War. Unprecedented numbers died during this conflict and while the final resting place of many was known, whether it be back home or in Europe, the nature of this war, fought largely in the mud of the trenches, meant that countless others were never found. The motivation for creating cenotaphs was therefore to establish monuments for all who died, and provide a place at which the bereaved who had no grave to visit could mourn their loved ones.

Jersey's Cenotaph is located in The Parade in St Helier. Created from granite by Charles de Gruchy, it features a symbolic coffin on top and was unveiled in 1923. One side of the monument is dedicated to the 'Glorious Dead', with *'Jersey A Ses Enfants Mort Pour La Patrie'* inscribed on another.

From the approximately 6,000 islanders serving in the British forces during this conflict, as many as 1,600 were killed. This was a significant loss for Jersey's population of around 50,000 at that time, and these numbers reflect Jersey's longstanding loyalty to the Crown and Britain.

Annually on 11 November, members of the forces, together with retired military men and women, join the public at the Cenotaph to commemorate those who gave their lives for their country in various conflicts. It is an important occasion to mark, and wreaths with vibrant red poppies laid at the base of the Cenotaph each year urge us never to forget.

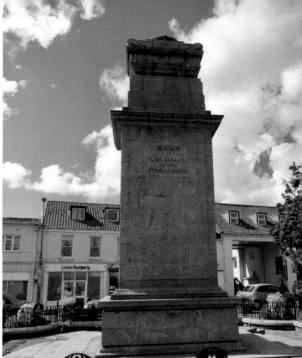

Above left: The Cenotaph, St Helier. (© Simon Radford)

Above right: The Cenotaph's inscription: 'Jersey À Ses Enfants Mort Pour La Patrie'. (© Simon Radford)

37. Barge Aground (The Seagull)

A Seaside Folly

If you were enjoying a day out in St Ouen's Bay in the time before Germany's occupation of Jersey, you would notice huts and bungalows dotted along the beach. One was a curious shape, and its name gives a clue as to what that is.

Barge Aground is a boat-shaped folly that today is the only survivor of those pre-war beach huts. It was built in the mid-1930s by Lionel Cox, and while he would have enjoyed time with friends and family at this quirky bungalow, Barge Aground (also known as Seagull) has been used for other purposes in the years since.

Requisitioned by the Germans during their five-year occupation, the building was camouflaged and converted into a soldiers' canteen. Returned to its original state following liberation in 1945, it was given to the Jersey Scout Association following Lionel's death in the 1950s. Briefly leased as a clinic for those with speech impairments, it was eventually reclaimed by the Scout Association.

It is now a Jersey Heritage holiday let, furnished in a style sympathetic to its glory days of the 1930s. Located within Jersey's National Park and the beautiful scenery of St Ouen's Bay, Barge Aground is an iconic landmark.

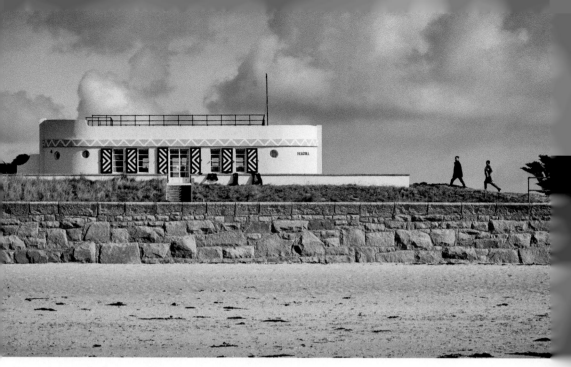

Barge Aground (the Seagull). (Courtesy of Visit Jersey)

38. The Airport

Connectivity in the Sky

Jersey's airlinks to the United Kingdom and Europe are vital. They allow tourists to visit, local travellers to explore the world and business to be transacted. They enable patients who can't be treated in Jersey's hospitals to access medical care in the United Kingdom, and the airport in St Peter is the hub for this incoming and outgoing airborne activity.

Although the first planes to land in Jersey in 1912 did so at low tide on the beach in St Aubin's Bay, this is fortunately no longer the case and passengers arrive and depart from the airport's purpose-built runway. Part of Jersey's early aviation narrative is still accessible though, with a section of the original airport terminal dating from 1937 incorporated into the current arrivals building. Its clean lines and curves provide an interesting contrast to the angles, glass and stone of the newer 1990s departures hall.

Since opening in the 1930s, Jersey's airport has operated through war and peace. Before the Second World War, the airport's terminals and four grass runways served people travelling on and off island. However, during the German occupation of Jersey, non-military travel was terminated, and the airport served as a base for the Luftwaffe or German air force, who replaced the grass landing strips with a concrete runway.

Jersey's liberation in 1945 meant that the airport could reopen for civilian travel, and thousands of war-weary British tourists seeking a holiday in an

English-speaking destination close to home began to arrive. Tourist numbers continued to increase, particularly throughout the 1950s and 1960s, with many attracted to the island for events such as the annual Battle of Flowers carnival.

Now, with numerous departure points in the British Isles and Europe, passenger numbers passing through the airport have swelled, with 1,715,952 recorded in 2019. The significance of air travel for Jersey, the need to accommodate larger planes in the future and to maintain the island's connectivity means that Jersey Airport will be redeveloped over the next few years, and a new chapter in its story will begin.

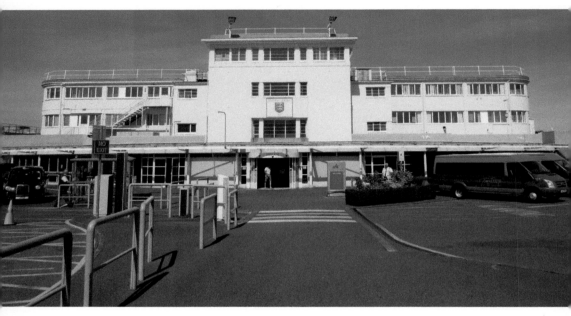

Above: The original airport building. (© Simon Radford)

Below: The airport's departure hall. (© Simon Radford)

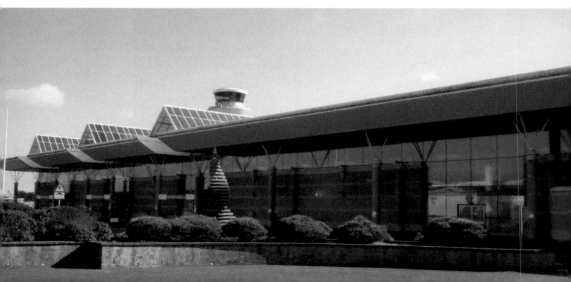

39. The Channel Island Military Museum

Insights into the Occupation Experience

The Channel Islands were the only part of the British Isles to be occupied by Germany during the Second World War, and the concrete anti-tank sea walls, bunkers and gun emplacements found in the islands are evidence of this time. Many of these structures now help tell the story of occupation from the perspective of

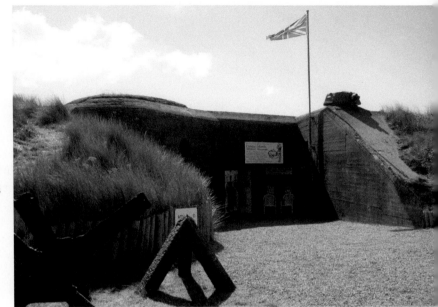

Right: Entrance to the Channel Islands Military Museum. (© Simon Radford)

Below: The Channel Islands Military Museum bunker. (© Simon Radford)

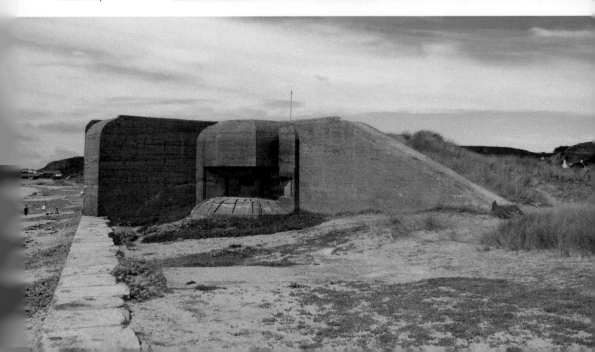

all who experienced it, whether they were the occupier or the occupied. One such building is a bunker that, while a physical reminder of occupation, also displays a comprehensive collection of German militaria and civilian Second World War artifacts, the result of one man's lifelong interest in this era.

The Channel Island Military Museum is housed in a 10.5 cm gun casemate, and standing above the beach, it would have loomed threateningly on the horizon for Allied forces attempting a counter invasion of Jersey. The walls of the bunker are a robust 2 metres thick and a gun crew of twelve would have operated the gun.

Damien Horn is the individual behind the museum which opened in 1989, and it is his collection of items, begun when he was seven years old, that are on display. Damien sources artefacts from Jersey and beyond, some of which are purchased, while others are donated, and each one reveals an aspect of this time. Original weapons, uniforms and memorabilia marked with Swastikas highlight German intent, beliefs and resources. Notices for the island's population communicating threats of punishment for non-compliance with German orders contrast sharply with Red Cross messages sent between islanders and their families in the United Kingdom. These show that despite being restricted, subject to severe punishment and threatened with deportation, the population doggedly continued to maintain the more 'normal' aspects of life, including news of births, marriages, death and gossip.

Damien's cache of authentic items is a tangible manifestation of a unique occupation, and the bunker, along with Jersey's other German-built structures, are, according to the Channel Island Occupation Society, 'the best-preserved ... German Second World War defence works in Western Europe'.

40. The War Tunnels

A Reminder of Darker Times

The War Tunnels are a 'must-visit' site and the exhibits, artefacts and commentaries presented here recount the occupation experience, not just from the islanders' perspective but also from that of the occupiers and those who built the tunnels. But why were the tunnels built and by whom? The answers to those questions lie in Hitler's suppositions, Nazi ideology and the course of the Second World War.

Once German dominance of Europe was established, Hitler began preparing for an Allied counter-invasion, and one of his initiatives was to create a line of defences stretching several thousand miles, from Scandinavia to the Pyrenees. The Channel Islands were the most heavily fortified parts of this Atlantic Wall and evidence of it can be found all over Jersey. The War Tunnels complex, part of this Channel Island stronghold and originally known as Hohlgangsanlag 8 (meaning tunnel system), was intended as a barracks and artillery store. However, by 1944 as Germany's hold on Europe weakened and with Allied invasion seeming inevitable, the tunnels became a casualty clearing station.

Above: The War Tunnels' entrance tunnel. (© Simon Radford)

Below: The War Tunnels. (Courtesy of Visit Jersey)

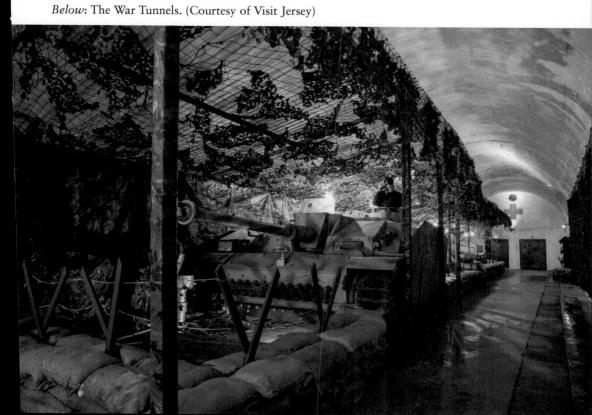

At least 1,000 metres of tunnels were burrowed out around 50 metres under the ground for this subterranean labyrinth, and this huge undertaking was carried out by over 5,000 slaves and forced workers. Blasting and digging these tunnels was dangerous and exhausting, but because the Eastern European slave workers carrying out this work were deemed as *Untermenschen* or racially inferior in Nazi doctrine, they were considered expendable. Groups including Spanish Republican prisoners were also involved in this toil, although the conditions they endured were not as horrendous as those suffered by Russian and Ukrainian slave workers. Part of an unfinished tunnel is on display today and its poorly lit damp interior, with the noise of falling rocks, enables visitors to comprehend, in just a small way, what the working conditions were for those who laboured in this environment.

The War Tunnels recount the difficult years of Jersey's occupation, and the very existence of the tunnels ensures that those who worked and died here are remembered.

41. Faulkner's Fisheries

Sea, Sunsets and Shellfish

Jersey's position as part of Hitler's Atlantic Wall is evidenced by the multitude of German defences built on the island. However, despite these structures being created for war, some are now used for more benign purposes like cafés and even a turbot farm.

This unlikely link between fishy matters and the Second World War continues at a bunker located on a promontory at L'Etacq. The concrete structure now

Faulkner's Fisheries with views of Corbière Lighthouse from L'Etacq. (© Simon Radford)

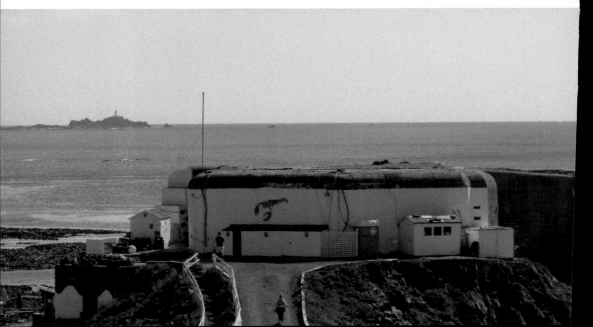

supports a family business and provides the perfect spot to savour barbecued local seafood in the summer months, while enjoying views of St Quen's Bay and the Atlantic waves that roll into shore here.

This is Faulkner's Fisheries, a business that buys and sells local and imported fish, and which was set up by Sean Faulkner in the 1980s. Live local shellfish including lobsters, crabs and oysters are stored within this bunker in tanks of regularly replenished saltwater pumped directly from the sea. Such a change in use means that the bunker is now referred to as a *vivier*, a place in which to store live fish, and it is a well-known landmark and popular part of Jersey's food scene.

42. Jersey Arts Centre

Creativity and Community

The arts are well supported in Jersey, and an impressive number of locals have excelled in the performing, visual and literary arts. These include artist and co-founder of the pre-Raphaelite movement, Sir John Everett Millais; Victorian actress Lily Langtry; Elinor Glyn, an early twentieth-century Hollywood film

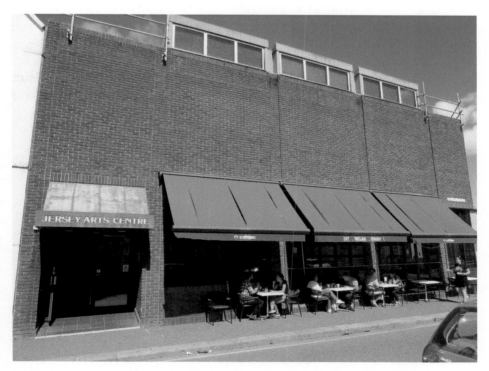

Jersey Arts Centre. (© Simon Radford)

director and scriptwriter; and, more recently, Henry Cavill, famed for starring as Superman and appearing in the Netflix series, *The Witcher*

Since the 1980s one island location where this local relationship with the arts thrives is the Jersey Arts Centre (JAC). This building's design is rational and efficient, and its interior is the perfect environment in which to stage a variety of exhibitions and productions that convey the light and shade of human experience. The JAC's Benjamin Meaker Theatre accommodates up to 250 people and performers have a Green Room and dressing rooms at their disposal. The Berni and Bar Galleries host art exhibitions, there is a popular café and the JAC is home to a vibrant youth theatre.

This is very much a community hub, whether you are participating or spectating in events, or just popping into the café to meet friends.

43. Elizabeth Harbour Terminal

Island Gateway

Entry into Jersey is via its airport, harbours and marinas, which are operated collectively as the Ports of Jersey. The building that manages the majority of the island's incoming and outgoing sea travel is the Elizabeth Harbour Terminal in St Helier.

Creation of the terminal and its harbour was prompted by increasing freight and passenger demands putting a strain on existing facilities at the Victoria and Albert piers (which you can also find out about in this book). In the

Elizabeth Ferry Terminal. (© Simon Radford)

1980s, a new passenger terminal and harbour with roll-on/roll-off facilities was consequently constructed. Outside space sufficient to manage embarking and disembarking vehicles, together with customs and immigration amenities, were also built, with the complex opened by Her Majesty Queen Elizabeth II in 1989.

The terminal's spacious interior hums with the activity of arriving foot passengers and those heading off-island for business and pleasure, whether on foot or by car. They travel from or to places like Guernsey, Portsmouth and Poole and some passengers take advantage of ferry services to the French port city of St Malo, which at just a 75-minute ferry trip away, gives access into Europe for them and their vehicles.

44. Pallot Steam, Motor and General Museum

A Tribute to One Man's Passion

Down a country lane in Trinity is a unique museum, the vision of an extraordinary man who wanted to share his passion and preserve the machines he loved. Pallot

Pallot Steam, Motor and General Museum. (© Simon Radford)

Left: Don Pallot's *Dolly May* steam engine. (© Simon Radford)

Below: Train rides at Pallot Steam, Motor and General Museum. (Courtesy of Visit Jersey)

Steam, Motor and General Museum pays homage to the steam age and also to the individuals, including the museum's founder, whose innovation and inventiveness created the machines on display here.

Lyndon (Don) Pallot was an engineer who, from childhood, repaired and invented all manner of machines. His interest in steam began when he was an engineer with the Jersey Railway, and his dream of establishing a steam museum was realised in the early 1990s.

Initially, machines were displayed in the Engine Shed, a structure previously used by Jersey's Territorial Army battalion, the Jersey Field Squadron. However, this space was ultimately not large enough for the multitude of machines that Don and his family collected. The museum was extended by adding a vast frame structure and enhanced further with the addition of galleries to provide extra space. This new-look museum opened in 2002 but sadly Don was not there to see it as he died in 1996, aged eighty-five.

Asked how and why the museum has such a comprehensive and eclectic collection, one of Don's eleven children Trevor (Sam) Pallot explained that the family are 'hoarders' and machines 'just seem to find' them. But there is still one thing that the museum covets, and this is the *La Moye*, currently located in South Africa and the only surviving locomotive from Jersey's railway, which closed down in the 1930s.

As well as displaying agricultural machinery, other exhibits include steam rollers, railway locomotives and carriages. There are Second World War military vehicles, vintage cars and tractors, and even several organs. But perhaps the most precious machine in the collection is *Dolly May*, an antique traction engine named after Don's wife of sixty-two years.

Last but not least, visitors can jump into Victorian carriages from the museum's station, and when taking a short ride on its railway, they'll appreciate Don's legacy and hopefully understand his love of steam.

45. Springfield Stadium

A Centre for Sport, Culture and Island Tradition

On its website, Springfield Stadium is described as Jersey football's 'spiritual home' and several of the Jersey Football Association's twenty-three clubs play their home matches here. Springfield accommodates up to 7,000 spectators and has amenities for other activities too, including yoga and general fitness. However, Springfield Stadium and grounds are not just about football. Its past and present are part of Jersey's bigger story and if you want to find out more, notably which rock star is said to have had fruit thrown at him during a concert here, read on!

Springfield's current facilities date from the 1990s but the site has had various uses since the Royal Jersey Agricultural and Horticultural Society bought it in

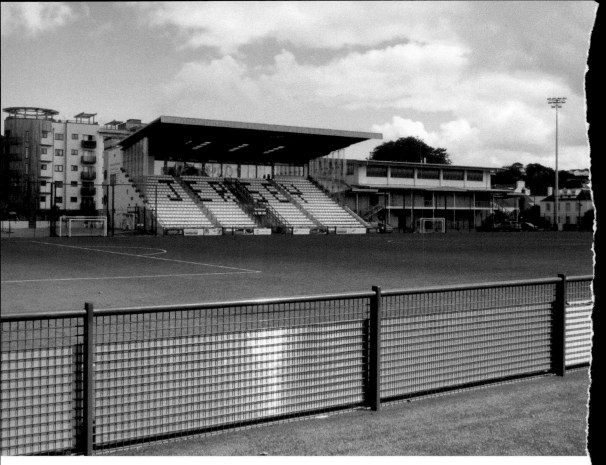

Springfield Stadium and grounds. (© Simon Radford)

the 1880s. The society used the grounds for its agricultural and cattle shows, which gave island farmers the perfect opportunity to showcase local produce and livestock, including the noble Jersey Royal potato and incomparable Jersey Cow.

Over the years, the addition of buildings like a ballroom meant that the nature of events held at Springfield could expand and a range of occasions and functions took place here. The Royal Militia of Jersey once paraded in the grounds and Jersey's annual Battle of Flowers carnival was held here in the interwar years. Concerts were popular and locals flocked to see bands like The Beatles, and it's here that Mick Jagger had an unfortunate encounter with a tomato, thrown by an audience member with excellent hand-eye coordination, during a 1960s Rolling Stones' performance.

This Springfield account now returns to football and to Jersey and Guernsey's annual soccer tournament, the vigorously contested and highly prized Muratti Vase. The islands host in alternate years, and in Jersey the final is played at Springfield, a tradition begun in the early twentieth century and interrupted only by two world wars. The most important point to note though before you turn the page, is that if you are in Jersey or Guernsey when the Muratti is being played, cheer for the team in red, not green!

46. Jersey Archive

Preserving Jersey's History

Storing hundreds of thousands of items of record, from parchment documents to digital material, Jersey Archive gives a voice to those who have come before. Whether it be a bankruptcy record, German Occupation identity card or local newspaper photograph, each record can help individuals and organisations engage with those who created them and learn more about Jersey's past.

The need to protect such items is not a new phenomenon, as emphasised by Jersey's 1858 Archive Law which sought to preserve official States' documents during the Victorian era. However, it was not until the year 2000 that a purpose-built archive for Jersey was opened, with an extension later added to increase its capacity.

Located in a former quarry on the outskirts of St Helier, Jersey Archive is constructed from materials like wood and glass and has a contemporary design. As a depositary for tangible elements of the island's history, the building's interior has been planned to provide an appropriate environment for the preservation of each item. The building's 'stack' architecture guarantees passive air movement throughout, which results in consistent humidity and temperature. Thick doors protect against fire and theft and items are stored inside nine strongrooms. Newly acquired records of various mediums are isolated in a quarantine room to ensure that unwelcome additions on or within them, such as mould or insects, are destroyed, and dirty items are dealt with in a cleaning room.

Jersey Archive's entrance. (© Simon Radford)

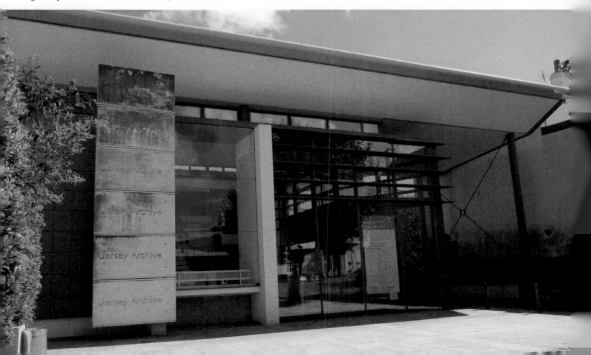

A strongroom at Jersey Archive. (© Simon Radford)

Additional storage facility at Jersey Archive. (© Simon Radford)

The purpose of the archive is not just to store historic items though, it is also a resource for all. Whether you are tracing your family tree or doing research for a book, the archive's records are available to view in the building or online. Talks and lectures given by archive staff also take place here.

With its German Occupation Archive recognised in UNESCO's UK Memory of the World Programme and accreditation by the National Archive, Jersey Archive is a priceless asset that Jersey Heritage accurately describes as 'sit[ting] at the heart of our collective understanding: who we are, where we came from, and indeed, where we are going'.

47. Liberty Wharf

Historic and Contemporary Multifunctionality

St Helier's buildings display a wonderfully diverse blend of design, function and history, and when walking around, it's possible to view many centuries of architecture in the town's squares, lanes and streets. One such example is Liberty Wharf, a collection of structures that combine old and new style and offer contemporary retail, dining and social opportunities, pursuits far removed from activities occurring on this site during the nineteenth and twentieth centuries.

Liberty Wharf was the location of Jersey's abattoir for many years. The Dutch gabled exterior walls that enclose today's complex are part of the abattoir's 1880s incarnation, and these stone walls with decorative pediments and curves shielded the public's gaze from what happened within. Integral to the external walls is the cattle inspector's house which dates from 1901, and this location ensured that his commute to work each day was very short.

Part of the Jersey Western Railway ran alongside the building and its St Helier Terminus, which opened in 1901, is now part of Liberty Wharf with its façade visible from Liberation Square. This building was designed by Adolphus Curry, a Jersey architect whose other creations include Highland's College and the Victoria Club (now Banjo's restaurant).

During the German occupation of Jersey and then the island's liberation on 9 May 1945, the Liberty Wharf buildings witnessed key events. In 1942, over 1,000 men, women and children were assembled here prior to being deported to Germany and their subsequent confinement in internment camps. On 9 May 1945, it was from a first-floor window that now looks onto the Liberation Statue that one of the first Union Jack flags to be seen following release from Nazi occupation was hoisted, and this window still has a flagpole beneath.

Liberty Wharf has had a varied story and the way in which it has been adapted manages to retain its historic integrity. Surviving Grade I listed elements of the original structure like its external walls create an authentic environment, with recent additions including open areas and skylights resulting in a space that is as welcoming as it is interesting.

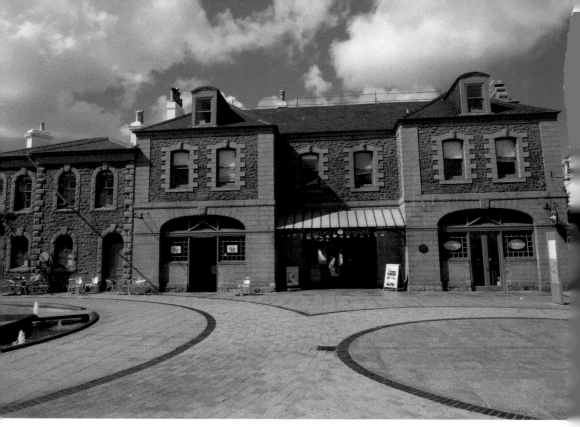

Above: Liberty Wharf (originally the railway terminus). (© Simon Radford)

Below: Liberty Wharf (originally the abattoir). (© Simon Radford)

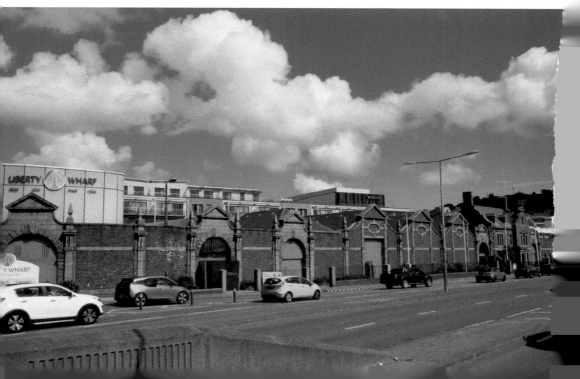

48. Wetland Centre

Up Close to Island Nature

Jersey has an abundance of natural environments and wildlife, and nineteen island locations, considered to be of 'zoological, ecological, botanical or geological interest', are designated as Sites of Special Interest (SSIs). One of these is La Mare au Seigneur or St Ouen's Pond, the Channel Islands' largest body of fresh water.

To protect this habitat whilst allowing people to enjoy its beauty, flora and fauna, the National Trust of Jersey built an interpretation centre here in 2014. Be warned though if you are planning to visit the Wetland Centre, you may not find it straight away as it blends so well into the area's natural surroundings.

The centre was designed to retain and reflect the environmental integrity of the area, and it is accessed via a timber entrance, with the whole structure covered in local grasses and sand. The interior is clad in wood with the shell of a beech tree cleverly concealing a steel roof support. Windows overlooking the pond allow those inside to observe the birds who nest, hunt and visit here. Exterior cameras capture the wildlife activity, and these images are relayed to screens inside. An unexpected part of the centre is a German occupation era concrete bunker that has been incorporated into the structure. This retains many of its original features and is now used as a classroom.

The pond's grasses, mud and reeds support a variety of avian residents, as well as migrating birds who stop to rest here. At various times of year, birdwatchers should see waders and warblers, tits and wrens, and this area is one of the best places in Europe to observe marsh harriers. Unusual visitors have included spoon bills, stilts and a desert wheatear, with creatures like mice, lizards and slowworms being regular inhabitants of the site.

Wetland Centre entrance. (© Simon Radford)

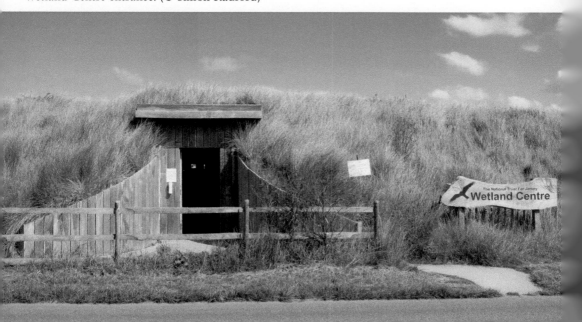

Left: Bird watching at the Wetland Centre. (© Simon Radford)

Below: Wetland Centre, St Ouen's Pond and St Ouen's Bay. (© Simon Radford)

The Wetland Centre is sympathetically designed and is an environmentally and ecologically appropriate building that facilitates human engagement with nature. It provides a domain in which all ages can learn about and appreciate Jersey's extraordinarily diverse wildlife and environment.

49. Gaspé House

Commerce, Canada, Cod

Employing over 12 per cent of the population, finance is Jersey's main industry and is accommodated within many of St Helier's buildings. One is the Royal Bank

Gaspé House. (© Simon Radford)

of Canada's Jersey headquarters, which, while its design belongs to the twenty-first century, has a name that reminds us of another industry that established strong links between this little island and the world's second largest country.

Completed in 2016, Gaspé House has six storeys, a glazed and polished granite exterior, and offices and meeting rooms overlooking St Aubin's Bay. It provides a contemporary environment in which to conduct the business of finance, which took off in Jersey in the 1960s, driven by factors such as the abolition of outdated anti-usury laws and introduction of new regulatory legislation. Such measures have helped Jersey become an International Finance Centre, with many of the world's foremost banks having a presence here.

But what of this building's name and those geographical connections mentioned above? Well to answer this, ponder on the following: it is the Jersey HQ of a Canadian bank; in the eighteenth and nineteenth centuries, Jersey men fished the cod banks off Newfoundland and Quebec and many of these men and their families eventually settled here, with one particularly popular location being, yes, you've guessed it, Gaspé.

50. Neolithic Longhouse

Ancient Living and Timeless Community Spirit

Jersey is one of Europe's most important archaeological areas and among the island's many ancient sites is La Hougue Bie, which you can read about at the beginning of this book. Situated close to this prehistoric place is a

twenty-first-century depiction of a Neolithic longhouse that shows how the people who constructed La Hougue Bie over 6,000 years ago may have lived. The Longhouse project was a collaboration between Jersey Heritage and experimental archaeologist Luke Winter, and took around 8,500 hours to build.

Little exists of Neolithic buildings above ground in Europe, so Luke's starting point for the Longhouse's form were post holes dating from this time, which were found in various European locations. Luke interpreted the positions of the poles to be the footprint of Neolithic dwellings and used this to form the basis of his design, with the structure gradually taking shape over three years.

To ensure authenticity, only hand-tools and natural materials were used in the build. Progress was slow and tasks included stripping bark off posts, which were then placed in 1-metre-deep holes using A-frames and brute force. Tree trunks were split, beams lashed with handmade cordage, walls were plastered with wattle and daub, and the roof thatched with reeds.

Volunteers were responsible for the building work with assistance from corporate groups and local schoolchildren. The project was very much a community achievement, which is likely to reflect the context in which these structures were originally built in Neolithic times.

The Longhouse requires continual maintenance to ensure it remains in good condition, so the volunteers remain busy. A fire often burns inside to keep the thatch dry; volunteers regularly refresh the wattle and daub and making replacement cordage is a frequent task for them. This group's dedication remains strong and they are rightly proud of their achievement. Longhouse volunteer Nicky Mansell notes that she has gained an appreciation of how sophisticated Neolithic people were, and how patient they must have been.

The Neolithic Longhouse is an educational resource, a fascinating place to visit, and site tours given by Jersey Heritage guides help visitors connect with their prehistoric ancestors.

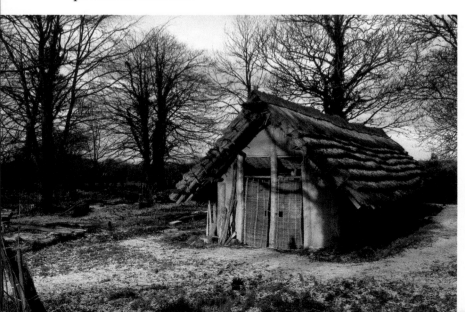

Neolithic Longhouse. (Courtesy of Neil Mahrer)

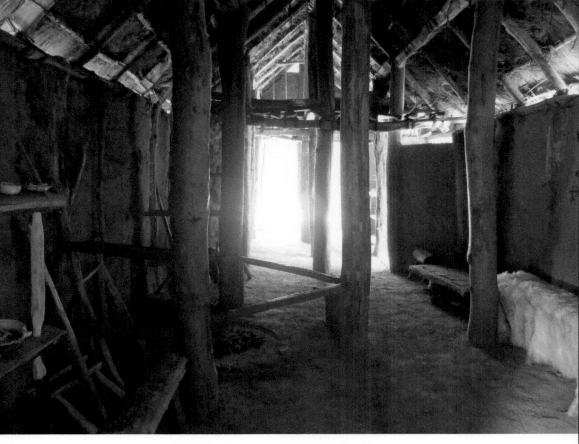

Above: Interior of the Neolithic Longhouse. (© Simon Radford)

Below: Neolithic Longhouse and vegetable garden. (© Simon Radford)

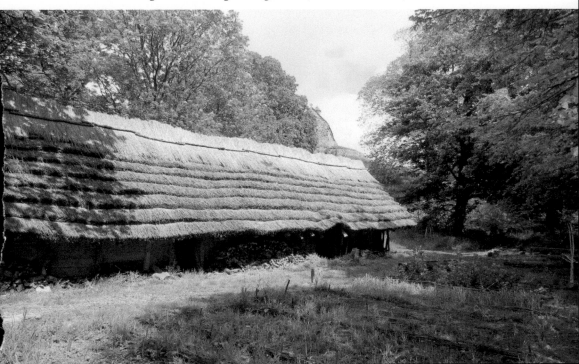

Bibliography

The following have been invaluable resources:

Carr, G., Sanders, P., and Wilmot, L., *Protest, Defiance and Resistance in the Channel Islands; German Occupation, 1940-45* (Great Britain: Bloomsbury Academic, 2014)

Davidoff, Leonore, and Hall, Catherine, *Family Fortunes; Men and Women of the English Middle Class 1780–1850* (Abingdon: Routledge, 2002)

De Renzi, Silvia, *The Healing Arts: Health, Disease and Society in Europe, 1500–1800*, (Manchester: Manchester University Press, 2004)

McCormack, John, *Channel Island Churches* (Chichester: Phillimore & Co. LTD., 1986)

Stevens, J., *Old Jersey Homes, 1500–1700*, (Jersey: The Commercial Art Company, 1965)

Syvret, Marguerite and Stevens, Joan, *Balleine's History of Jersey* (Jersey: Société Jersiaise, 1998, 2011)

www.active.je/centres/springfield
www.britannica.com
www.cios.org.je
www.gov.je
www.theislandwiki.org/index.php/Jerripedia
www.jerseychamber.com
www.jerseyfinance.je
www.jerseyheritage.org
www.jerseynationalpark.com
www.jerseywartunnels.com
www.nationaltrust.je
www.stbreladesbayhotel.com

Acknowledgements

The author and publisher would like to thank the following organisations for permission to use copyright material in this book: Visit Jersey and the States Greffe.

Every attempt has been made to seek permission for copyright material used in this book. However, if we have inadvertently used copyright material without permission/acknowledgement we apologise, and we will make the necessary correction at the first opportunity.

Sincere thanks also go to the following who have generously given their time and support whether it be in telling a story, helping my research, sourcing images or proofreading: Kary Day, M.I.T.G., Michael Day, C.V.O., Commodore David de Carteret and Chris Parlett, Gerry Flynn, Neil Harvey, Damien Horn, Colin Isherwood, Jersey Archive and Jersey Heritage, Malcolm Lewis, Charles and Georgina Malet de Carteret, Nicky Mansell, MITG, Capt. BJS Nibbs RD, Sam and Liz Pallot, Jean Trevelen, Gerald Voisin, James Wooldridge and of course, my son Barney De La Cloche, whose photos I'm very proud to feature.

Finally, a loving thank you goes to my husband Simon for his endless patience, encouragement, and for the hours he has spent proofreading my text and taking images for this book. I couldn't have written it without you.

About the Author

A dedicated historian with a degree in history, Tracey Radford moved to the island, home of her parents and grandparents, in her late teens. Raised on tales of Jersey life from her Jersey-French grandmothers, Tracey's love of Jersey, appreciation of its natural beauty and understanding of its culture and history led to her becoming a site guide for Jersey Heritage, author of local interest books and a qualified Blue Badge Tourist Guide. Tracey is also a founding member of Jersey Uncovered, a team of professional, registered tourist guides whose tours and bespoke experiences help visitors, as well as locals, discover all things Jersey, from the Palaeolithic era to the present day.

The author, Tracey Radford. (© Barney De La Cloche)